ll that they b...
res wishes & wants
wish harder
come true we
starstuff & stories
dip your pen
thoughts & words
you are remember
& see what
all that it is

inkspired

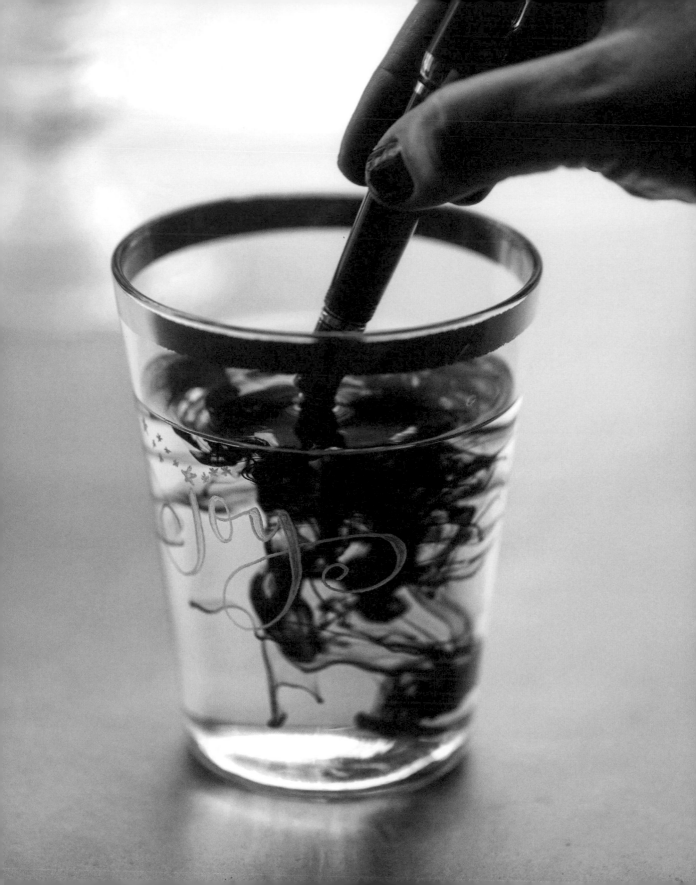

CREATING CALLIGRAPHY

inkspired

Betty Soldi

PHOTOGRAPHY BY DEBI TRELOAR

KYLE BOOKS

TO THOSE WHO INKSPIRE,
AND DON'T EVEN KNOW IT...

FOR ALMATTEO, MY SHOOTING STARS

» A SHOOTING STAR MEANS YOU HAVE A CHANCE
TO MAKE ALL OF YOUR DREAMS COME TRUE

An Hachette UK Company
www.hachette.co.uk

First published in Great Britain in 2017 by
Kyle Books, an imprint of Kyle Cathie Ltd
Carmelite House
50 Victoria Embankment
London EC4Y 0DZ

10 9 8 7 6 5 4 3

ISBN 978 0 85783 433 1

Calligraphy: Betty Soldi
Design and Creative Direction: Betty Soldi
Layout: Claudia Astarita
Photographer: Debi Treloar
Stylists: Betty Soldi, Simone Bendix, Helene Schjerbeck
Project Editor: Tara O'Sullivan
Editorial Assistant: Isabel Gonzalez-Prendergast
Production: Nic Jones, Gemma John and Lisa Pinnell

A Cataloguing in Publication record for this title is
available from the British Library.
Printed and bound in China

CONTENT

WHEN STARS COLLIDE ★ 6

INKTRODUCTION BY MARA ZEPEDA

BEGINNINGS ★ 8

ABOUT ME, ABOUT CALLIGRAPHY AND ABOUT YOU

WELCOME BACK TO WRITING ★ 28

EXPLORING YOUR OWN HANDWRITING, PUTTING PENCIL AND PEN TO PAPER

ALPHABETTY ★ 73

MAKING CALLIGRAPHIC LETTERFORMS

ALPHABETTER ★ 103

OPPORTUNITIES TO FLOURISH

CALLIGRAFUN ★ 117

EXPLORING DIFFERENT TOOLS LIKE BRUSHES AND EVEN VEGETABLES

POINTED-PEN CALLIGRAPHY ★ 126

USING POINTED PEN AND TIPS FOR THE LEFT-HANDED BY MARA ZEPEDA

WORDS MATTER ★ 141

WRITE ON WHITE AND PAPERCUT HEAVEN

BRINGING WRITING TO LIFE ★ 148

CREATIVE IDEAS TO BRING YOUR CALLIGRAPHY OFF THE PAGE

In 2012, my husband and I packed up our lives and moved to Florence, Italy, for a year. I arrived with laughably few basic Italian sentences, a copy of *Room with a View* and no friends or structure to my day. In the morning I would complete my calligraphy orders – most of these were designing tattoos (more on this later) – and in the afternoon I'd wander the streets and take in the sights.

WHEN STARS COLLIDE...

One day I was exploring Via Maggio, a short walk from our villa. I came upon a small storefront exploding with life. There was a riot of calligraphy on the windows, paper dresses, vintage furniture, mirrors and tiny porcelain birds with writing on them, collections of pencils, Warhol-esque artwork. I stepped inside and my eyes darted to the back, towards a wall of packaging embellished with the most soulful calligraphy I had ever seen.

'Who created this?' I asked.

And that is how I met Betty Soldi. My guide had arrived: fluent in English, clad in Prada sneakers, covered in ink, and leaving a literal trail of glitter and stars everywhere she went (ask anyone and they will tell you).

This was the beginning of the most profound artistic collaboration of my life. Most days I'd head to the shop at Betty's urging. 'Come play!' she'd text. I experienced facets of that world I never knew existed. Some days we'd visit an artist's studio and learn about his intricate painting process. Other days we'd rummage through marbled paper and heaps of party supplies and confetti. During the olive harvest I'd be invited to the *frangitura*, or oil pressing. On one occasion I was called to write on glass baubles at Betty's cousin's fireworks shop for Christmas; on another to attend a dinner party at a silver factory. Some afternoons we'd just browse the pens at the art supply store down the street. On busy days at her shop I'd wrap gifts with her, making sure to sprinkle glittery stars inside every package.

The following spring, Betty and I held our first calligraphy workshop together in a stunning library that overlooked the Arno river. The tables overflowed with expressions of love, scraps of paper and tendrils of ribbon. At first, the energy in the room felt like that of a family reunion. After a few hours, a peaceful quiet descended. We could see what was happening as plain as day: through the calligraphy exercises, each person was reuniting with themselves.

This is what Betty Soldi has set out to do in these pages: to help each of us to find our own voice, to reconnect with our own body, breath, and desire to express ourselves in the world. You will see that Betty's work has an energy and vivacity to it that leaps off the page.

The flourishes pull at your heart, and each word has a life of its own. If you make a pilgrimage to the universe that Betty and Matteo have created in Florence you'll see this energy in action. Her boundless imagination inspires us to see the world differently, as a place where beauty and possibility live everywhere we look. And, most of all, that they live inside us. To find this inspiration, all we have to do is *inspirare*. Breathe in.

Mara

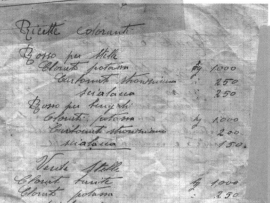

 ↑ My grandfather's handwritten notes on how to compose coloured fireworks, early 1900s.

Starstruck BEGINNINGS

My lucky star shone bright as I was born into a Florentine family that has been handmaking fireworks since 1869. I grew up surrounded by gunpowder and sulphur, silver dust and the craftsmanship of kraft paper and string – creative hands that touched, tore, creased and crammed, giving life to explosions and adding more stars to the sky. From a very young age, I was surrounded by people who celebrated the idea of creating with their hands.

When I was seven years old, I moved from Italy to London with my parents and sister. On my first day of school, I didn't understand any English, but I still remember being wowed by the teacher writing the alphabet on the blackboard, seeing chalky letterforms magically appear, each with their own shape and meaning, look and feel...

I have loved letterforms ever since.

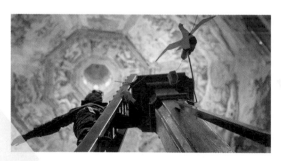

← Fireworks being rigged by my cousin for the traditional Easter Scoppio del Carro *inside the* Duomo *of Florence Cathedral.*

Now I make fireworks with ink

↗ *Pirotecnica Soldi fireworks on the Ponte Vecchio, Florence, 1950.*

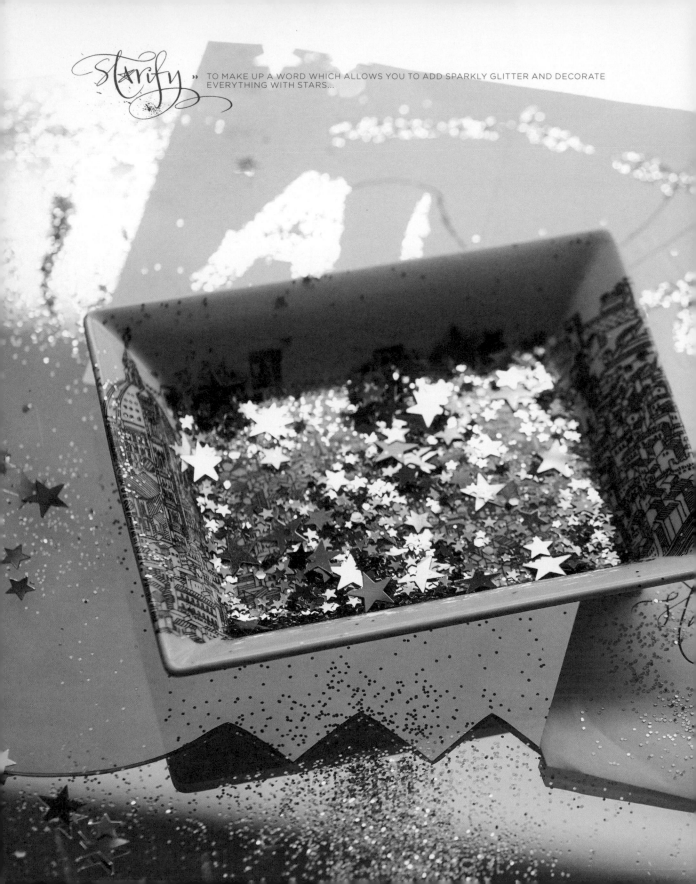

starify » TO MAKE UP A WORD WHICH ALLOWS YOU TO ADD SPARKLY GLITTER AND DECORATE EVERYTHING WITH STARS...

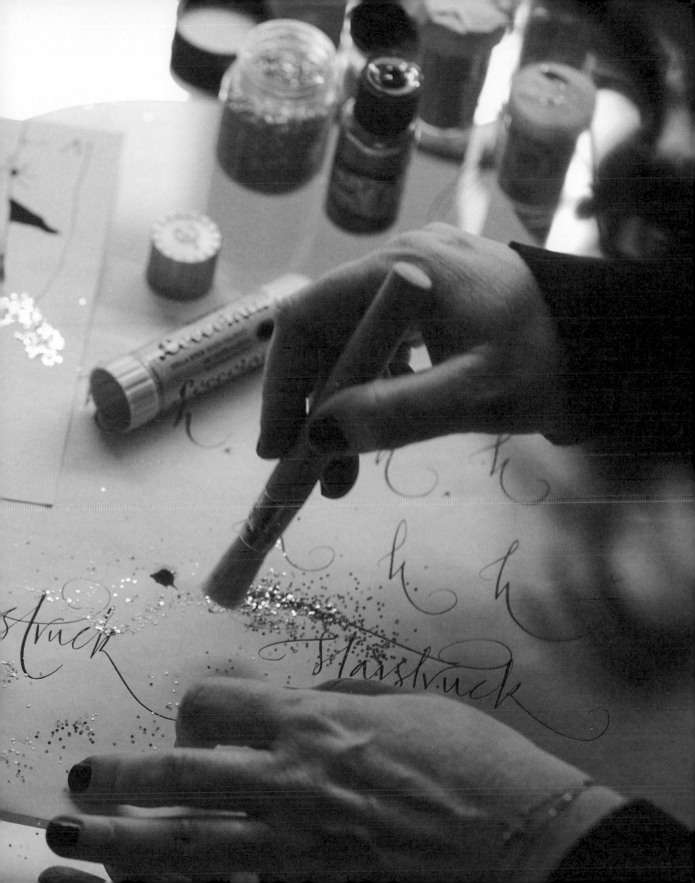

WORDSMITH

» A PERSON WHO WORKS WITH WORDS;
ESPECIALLY A SKILLFUL WRITER

Fast forward many years: I never did much art at school, but I did love to scribble and wordsmith. After following quite an academic path, I wanted to get in touch with my creative side. I returned to Florence for my gap year, found a design course and tried to make up for my lack of drawing skills. When instructed to draw a flower using any medium, I doubted my ability to draw. Instead, I inkily wrote *'Fiore'* in the shape of a flower.

'Bravissima!' I was told – and my destiny was set. I realised how much can be achieved by celebrating weaknesses as well as strengths. It can help us to find more creative solutions.

A love of typography led me to a BA in graphic design and communication at Ravensbourne, a London college based on the principles of the Bauhaus – a focus on simplicity and function. Craftsmanship was revered, and I was taught calligraphy in a way that extended from the traditional forms to just going crazy with it and experimenting. Although at odds with the Bauhaus principles of stripping away decoration to leave clean lines of function, my Renaissance soul loves it all, the old and the new.

In my calligraphy and design work for the worlds' leading retail brands and luxury labels, I merge handwriting with old or modern type, striking colours and unique antique touches to produce branding, packaging, bespoke objects and stationery.

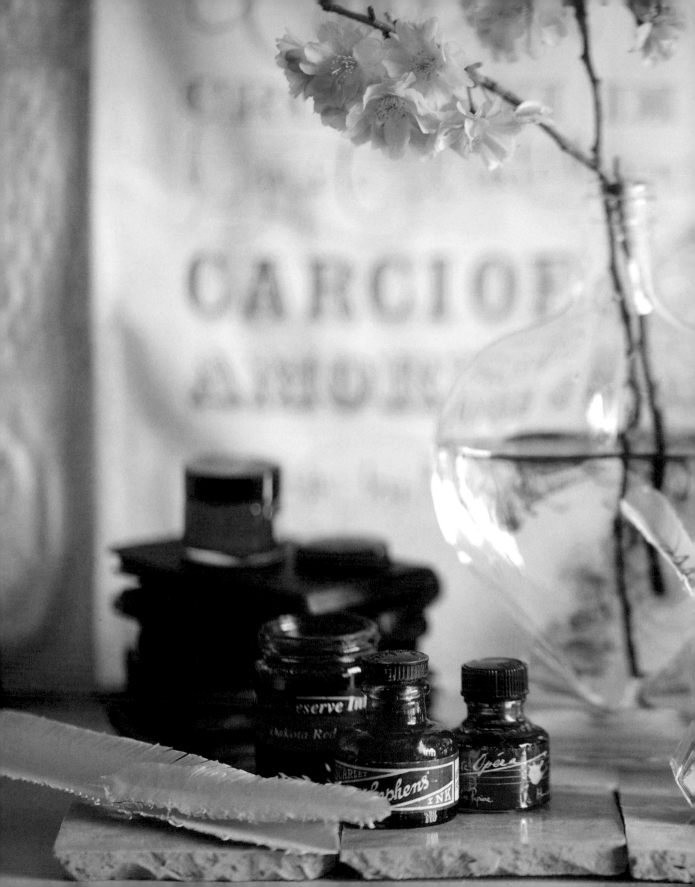

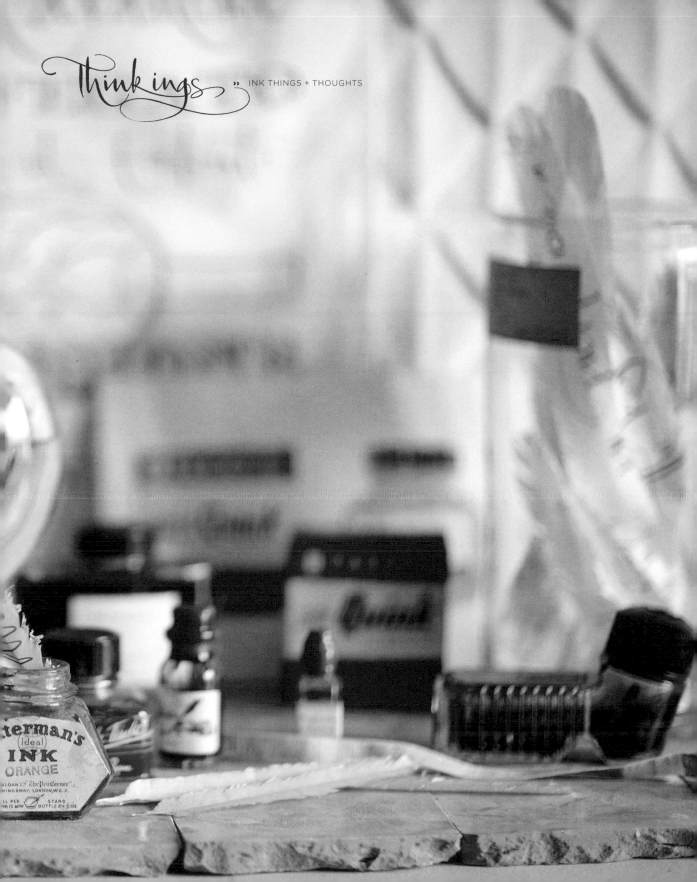

I now have a creative design studio and store back home in Florence. I extend my inky wordsmithing not only to paper and packaging but also bring it to life on ceramics, fabrics, marble, candles, perfumes and interiors. My partner Matteo and I recently opened two unique boutique bed and breakfast hotels in the quirkier, more artistic and artisanal Oltrarno area of Florence. We decorated each room in a distinctive style, and my calligraphy can be found on the walls, plates, pillows, windows… wherever there is space for a handwritten message.

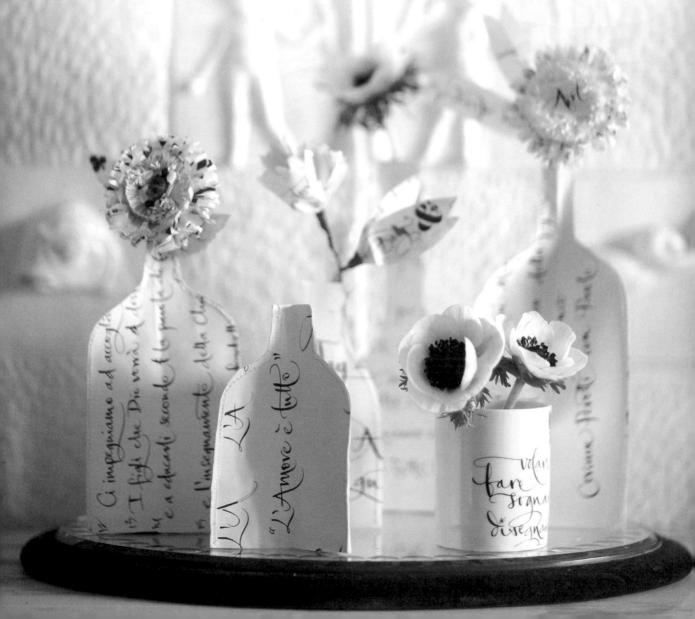

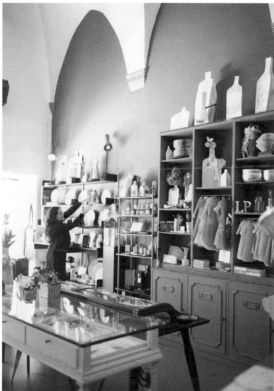

 Me and Matteo.

↑ *Views of my design studio, &CO shop,
detail of writing on a wall at our AdAstra hotel.*

we are all made
of scribbles
and stars

COLLECTING WORDS

I love all things wordy. I have always collected them, these compilations of scribbles, hand-formed letters and old type samples to get ideas for different ways to write words and names. Although a wealth of creative ideas can be found on Pinterest and Instagram, I suggest you begin by stepping away from the screen. Gather energy from different sources, breathing in words that are all around.

On my travels, and above all now that I live in the beautifully artistic city of Florence, I constantly look up and around to notice and discover sculpted typefaces, hand-painted votives in churches and on tombstones, Roman numerals, marble letters, peculiar age-old double sequences of Florentine street numbers (in red for shops, black for houses), original gold leaf shop signs, amazing forged manhole covers with curved type, illuminated manuscripts in museums and constant moments from the wonderful world of words – hopefully to be used as inkspiration somewhere, someday...

So the first activity is to go out and look for words and lettering – street signs, menus, shopfronts, graffiti, slogans on T-shirts. Learn to look out for words everywhere you go and curate your own collection.

Collect » TO CHOOSE AND GATHER TOGETHER

The reason you are here, reading this book, is The Hero's Journey. We are all on one. When I run calligraphy workshops, people often arrive feeling nervous. Trying something new and creative is exciting, but it can be intimidating too. At the start of this inky adventure you may feel overwhelmed, worried that you are not good enough or this is all beyond your capabilities. Be aware of this fear and, strange as it sounds, try to embrace it. Getting out of your comfort zone is the first step towards getting really creative, when inkspiration and motivation will appear...

THE JOURNEY

We see it everywhere: from Harry Potter to Luke Skywalker in *Star Wars* to Dorothy in *The Wizard of Oz*: the hero leaves home, is called to adventure, meets a teacher or guide, crosses into a new world, encounters adversity, faces the most challenging ordeal, reaps the reward of what they have learned and returns, stronger than before. The theme of the hero myth is universal, occuring in every culture, in every time.

This narrative started centuries ago, with Homer's *Odyssey* and *The Epic of Gilgamesh* as early examples, as well as one close to my heart, Dante's *Divine Comedy*:

→ *Moments of Florentine life:*
views and architecture inform my calligraphy,
details are transformed into ink.

Living in Florence, I pass the fourteenth-century poet Dante's birthplace almost every day, and am reminded of his cathartic course, from entering the dark wood (a symbol of being lost in life), descending to witness the karmic fate of souls in hell and purgatory, eventually reaching paradise with the guidance of Virgil and his love for Beatrice. At the end of the *Inferno* they 'ascend... to see again the stars' – from darkness to light, negative to positive, self-doubt to clarity. So try to see this book as your own journey, working through any self-doubt to confidence as you reconnect with the written word. In the pages that follow, my hope is to be your encouraging inkspiration, helping you along your path towards revealing your creative side. Journeying together we will see the stars, which shine even in the daylight.

LE COSE SONO UNITE DA LEGAMI INVISIBILI...

Non puoi cogliere un fiore senza turbare una stella *****

EVERYTHING IS CONNECTED

You already know how much Florence inspires me. I know I am fortunate to be walking on the same streets that Leonardo da Vinci, Michelangelo, Dante and the Medici once stepped on. But everyone has their own Florence. You just need to look around you to find it.

Wherever you are, you can be inkspired to create and connect. There is so much beauty to be made and remade – and by creating and sharing our work, we join the network of invisible threads that link us to others who have gone before us.

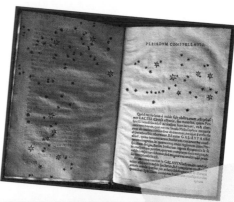

→ *Galileo's drawings of the Pleiades star cluster and Orion constellation, 1610*
↓ *and a sample of his handwriting, which says 'the greatness of the stars'.*

↘ *In one of our hotels hangs a copy of an anonymous painting – I wrote the Galileo quote in a gold marker directly on the canvas, in a concentric circle, to animate its darkness.*

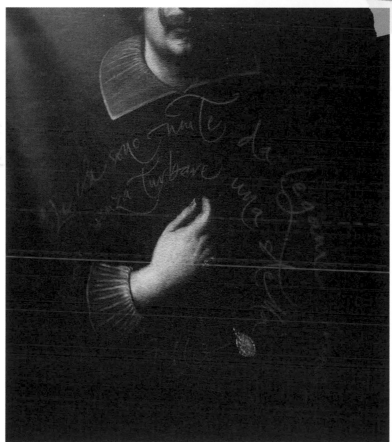

le grandezze delle stelle

We all learn to write as children. At first, we copy the way a teacher shows us, as best we can. Sometimes we mimic elements of other people's writing, like dotting 'i's with a small heart! ♥

WELCOME BACK TO WRITING

But generally, after childhood, as we grow up, we change hairstyles, clothes and friends – yet our handwriting stays the same. And worse, we use it less and less. Where our ancestors and parents wrote journals and letters by hand, these days we often rely on text messages and emails. Sometimes we only pick up a pen to hastily scribble a shopping list or something fleeting on a Post-it. But the truth is, there should be a place for writing in our modern world. We forget writing is so very personal and empowering when we take it into our own hands. Words are already loaded with meaning and emotions when spoken. They become even more so when written down – visible, touchable, keepable.

In this book, we will start with your existing handwriting and explore ways of developing it to express your personality. This is not intended as a manual or handbook (although I love that both words are about using your hands!). This is more of a conversation, a creative journey together where I share some ideas and encourage you to get inky fingers as you develop your own. Although I will show you my own 'Alphabetty' of calligraphic letterforms, the idea here is not to learn to write exactly like me – it is to learn to write more like *you*. Individual modern calligraphy should be about being different and unique, rather than simply replicating someone else's series of strokes. Let your personality shine through what, and how, you write.

Giorno

People are often drawn to me because of my handwriting – they notice and admire it and instantly tell me they are ashamed of theirs. Writing is a skill we all have and yet often we don't give value to developing it, transforming it from a habit to a joyful art that is all our own. My writing is curly and flourished, and someone once told me it reflected my curvaceousness, which makes me wonder if we can get a sense of what people are like by the way they write. And, like our star signs, can we understand ourselves better and perhaps develop our own creativity by developing our writing?

SO LET'S BEGIN BY LOOKING MORE CLOSELY AT YOUR EXISTING HANDWRITING AND TRY SOME EXPERIMENTS TO SEE WHAT IT IS CAPABLE OF.

TOGETHER WE WILL EXPLORE THE DARK, INKY WOOD OF WRITING ADVENTURES. LET'S TRY OUT NEW WAYS OF SHAPING LETTERS, OF LOOKING AT WORDS AND SEEING THE SPACES BETWEEN THEM TOO.

Magic is in your hands

A CREATIVE INKLING

As very young children we splat, scribble, make marks and draw without self-consciousness, giving shape to freedom and expressing ideas, thoughts and fears. Nothing is suppressed – alas, that comes later! As we get older, we lose some of this freedom and become more inhibited. We learn that it is 'correct' to colour inside the lines, to write in a straight line and obey the margins, to make our letters uniform.

Let's try to get back to that freer, more playful approach. In the pages that follow, we will do some exercises to try to help you loosen up and let your personality flow onto the paper along with the ink.

Drawings by Alma, age 6 ½

EVERY CHILD IS AN ARTIST

**'EVERY CHILD IS AN ARTIST – THE PROBLEM IS STAYING AN ARTIST WHEN YOU GROW UP.'
(PABLO PICASSO)**

this is my handwriting

It reflects my personality with individual quirks that appear when writing spontaneously.

—

THIS · IS · MY · LETTERING,

Lettering is a skillful evolution of drawing letterforms for them to become a more decorative and personalised illustrative type.

—

this is my calligraphy

Classical calligraphy is the art of mastering traditional letterforms and producing artistic, stylised and elegant handwriting. My modern take on this is artful writing with more thought and skill and conscious awareness.

Calligraphy can be viewed as an exact science, but the beauty of the journey to developing your own calligraphy style is that this doesn't have to be accurate or perfect. Much of it is intuitive and you will make exciting mistakes while learning and trying a new freeform and flourished style of writing, opening yourself up to imperfections and unique quirks that are personal to you.

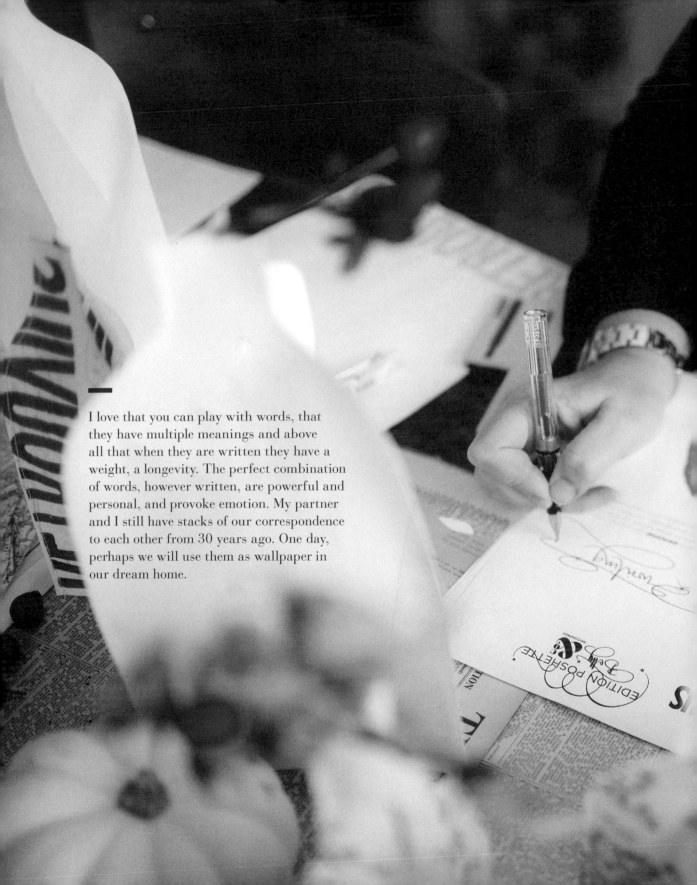

I love that you can play with words, that they have multiple meanings and above all that when they are written they have a weight, a longevity. The perfect combination of words, however written, are powerful and personal, and provoke emotion. My partner and I still have stacks of our correspondence to each other from 30 years ago. One day, perhaps we will use them as wallpaper in our dream home.

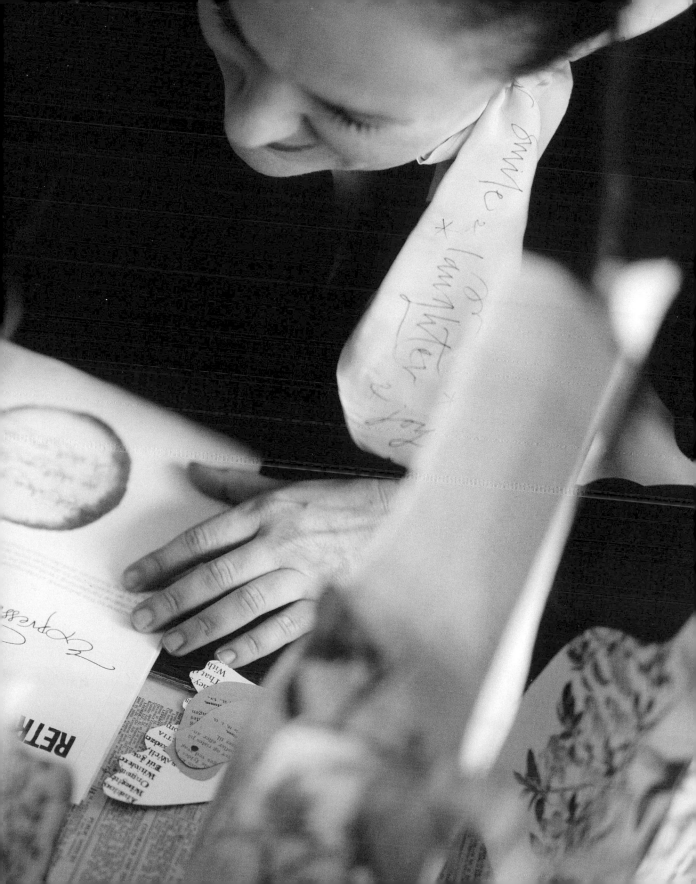

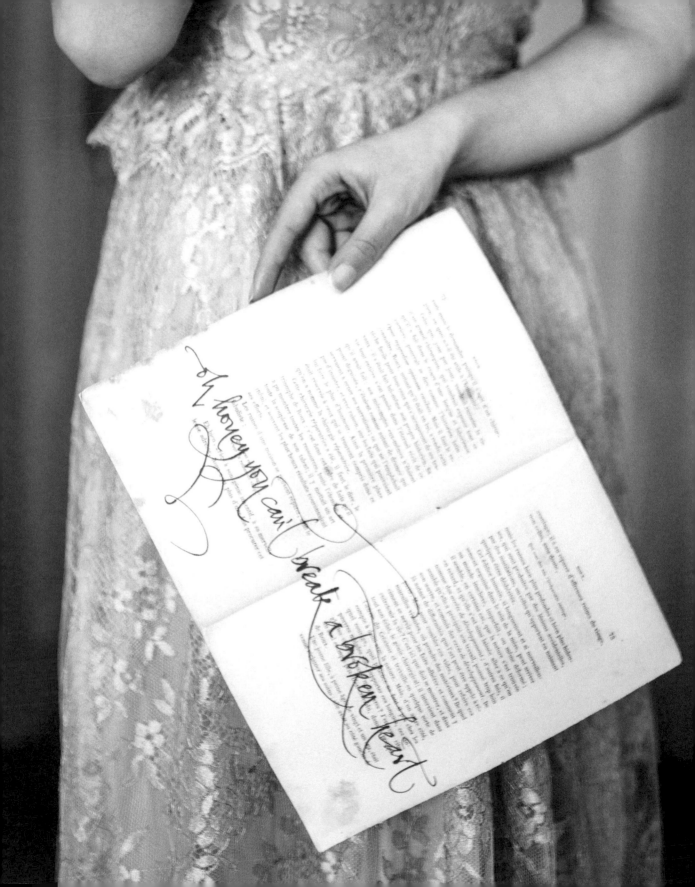

A sample of Michelangelo's handwriting, 1550s.

EFFORTLESS TAKES EFFORT

The powerful, visionary Florentine Medici family had an oxymoron as one of their family mottos:

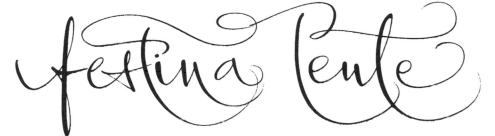

literally, 'make haste slowly' – but philosophically 'to advance and grow and make progress, with tremendous thought and care'.

When I write, I do so super-fast, instinctively, confidently. It looks effortless, but it has taken work, commitment, curiosity and time. With experience I have learned to anticipate the next move and envisage how to fill spaces, but it was not always like this – make sure you slow down when you are beginning to write more again, so that your mind catches up with your hand movements and you do not rush illegibly. We are trying to find a flow, a rhythm and consistent movements in lettering freedom. What thrills me most is that my writing continues to evolve. It is like a shooting star: I let it take me somewhere. Some of it is controlled, but most of it is trusting and letting go, embracing and loving the surprise of whatever starstuff appears.

ho visto un angelo nel marmo ed ho scolpito fino a liberarlo *

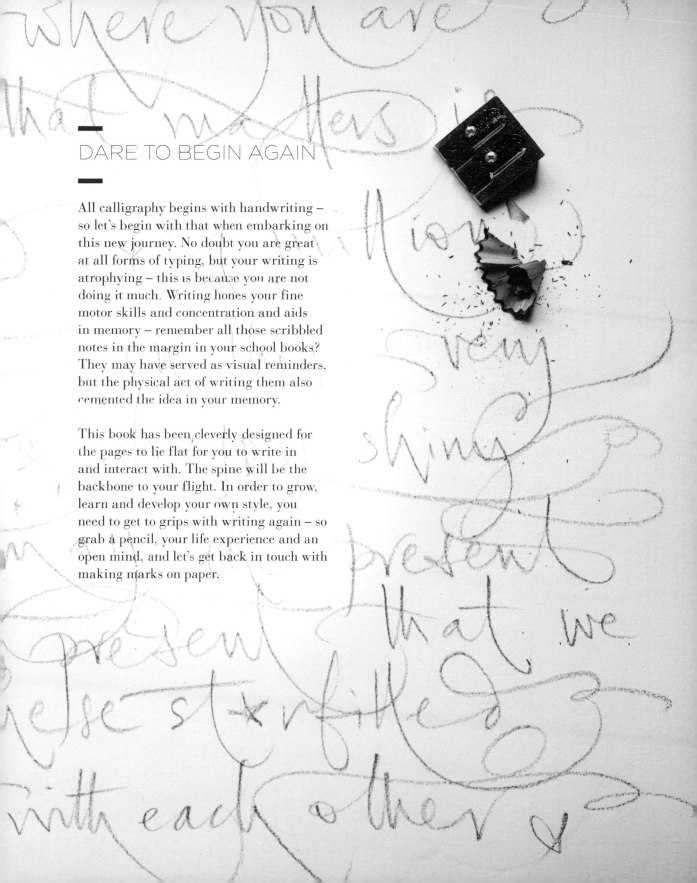

DARE TO BEGIN AGAIN

All calligraphy begins with handwriting – so let's begin with that when embarking on this new journey. No doubt you are great at all forms of typing, but your writing is atrophying – this is because you are not doing it much. Writing hones your fine motor skills and concentration and aids in memory – remember all those scribbled notes in the margin in your school books? They may have served as visual reminders, but the physical act of writing them also cemented the idea in your memory.

This book has been cleverly designed for the pages to lie flat for you to write in and interact with. The spine will be the backbone to your flight. In order to grow, learn and develop your own style, you need to get to grips with writing again – so grab a pencil, your life experience and an open mind, and let's get back in touch with making marks on paper.

—

 **TO START, LET'S KEEP IT BEAUTIFULLY SIMPLE – MAKE PENCIL MARKS HERE –
YES, WRITE IN THIS BOOK, MAKE IT YOUR OWN!**

—

Fill this space with lines: wobbly, straight, however they come out.
Notice both the lines and the spaces between them...

A **LINE** IS A **DOT** THAT WENT FOR A WALK... (PAUL KLEE)

When you start playing with calligraphy, you will see that the spaces and shapes between the letters and words are as interesting as the marks themselves.

Write some words really s m a l l.

miniscule

Now write just one word REALLY BIG

HOW DOES YOUR HANDWRITING CHANGE WHEN YOU ADJUST THE SIZE?
WHICH FEELS BETTER?

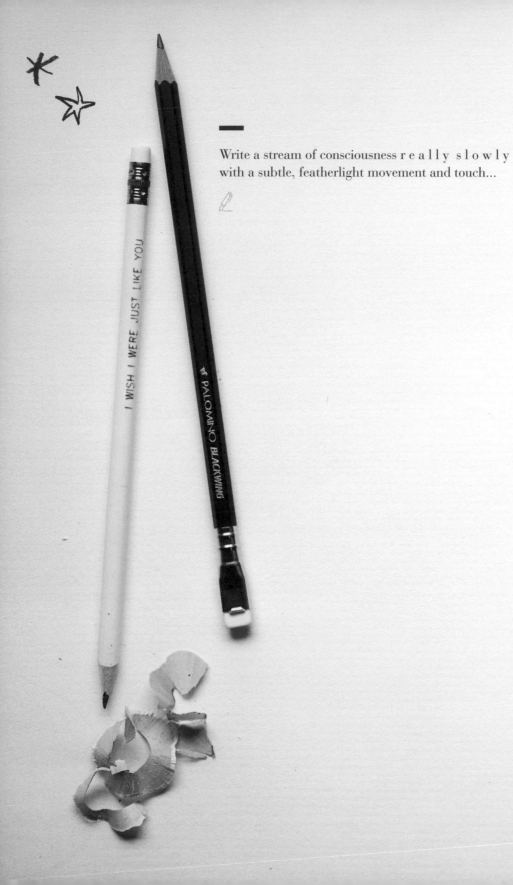

Write a stream of consciousness r e a l l y s l o w l y
with a subtle, featherlight movement and touch...

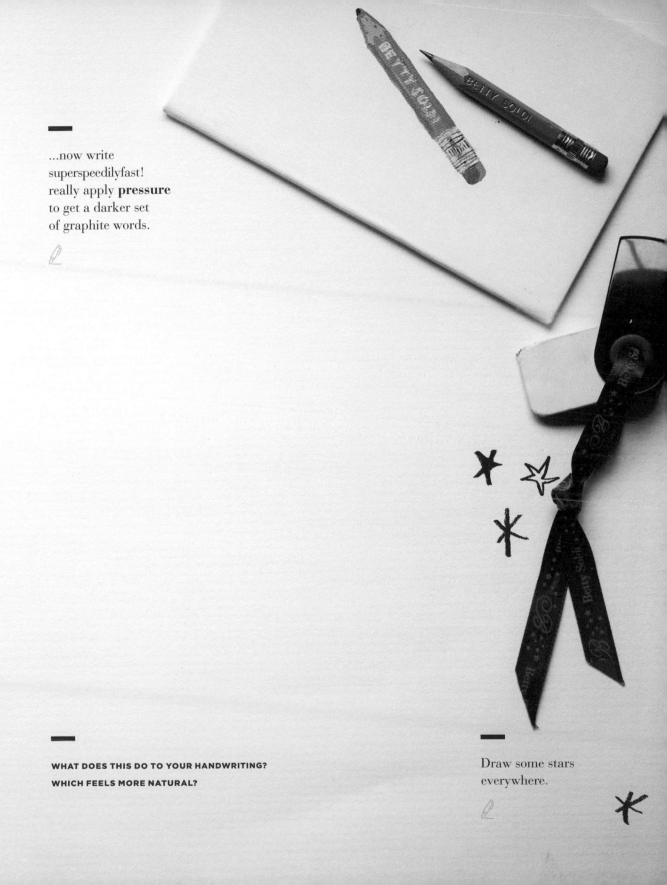

...now write
superspeedilyfast!
really apply **pressure**
to get a darker set
of graphite words.

WHAT DOES THIS DO TO YOUR HANDWRITING?

WHICH FEELS MORE NATURAL?

Draw some stars
everywhere.

Write something here with your eyes closed.

DOES IT STILL LOOK LIKE

YOUR HANDWRITING?

sinistra

» **'LEFT'** IN ITALIAN, FROM THE LATIN 'SINISTER' – MEANING HARMFUL OR EVIL, AS IT WAS ONCE
THOUGHT THE DEVIL WAS ASSOCIATED WITH THE 'MALICIOUS' LEFT-HAND SIDE...

Now write it again with your eyes open, but using your other hand.

HOW DOES IT FEEL TO WRITE WITH THE 'WRONG' HAND? IS THERE
ANYTHING YOU LIKE ABOUT HOW THESE LETTERS LOOK? YOU HAVE LESS
CONTROL HERE – IT MAY MEAN THAT SOMETHING NEW HAPPENS...

» 'RIGHT' – DEXTEROUS – SHOWING OR HAVING SKILL WITH THE HANDS

It's time to progress from pencil to ink. Just inkcase you were thinking you needed all sorts of specialist tools, you should know that every calligrapher started with a pencil or a simple pen. To focus on developing your knowledge and skill of letterforms, we'll begin by using a fountain or cartridge pen. Let's play!

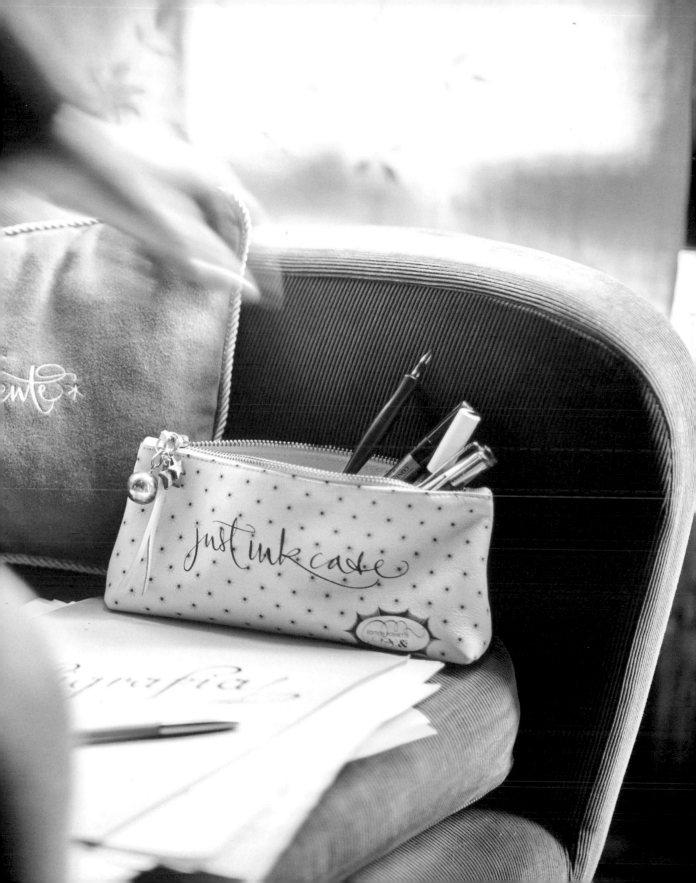

Wabi Sabi » BEAUTY THAT IS IMPERFECT, IMPERMANENT AND INCOMPLETE

Before we start, let me say this. Perfection is overrated. Authenticity has far more beauty. Handwritten mistakes are difficult to repeat and as such are to be celebrated. In the Japanese art of *Kintsugi*, broken objects are repaired using gold; flaws are seen as part of the history of an object, rather than something to disguise. The damage is not hidden, instead the repair is literally illuminated. It shows us that there is beauty in everything – even, or especially, in the imperfect – so relax and just see what happens.

write your heart out

↗ *A rare antique heart-shaped*
wooden frame fell and broke.
I repaired it with bandages,
making them part of its beauty,
and wrote directly on
the wall – no glass required...

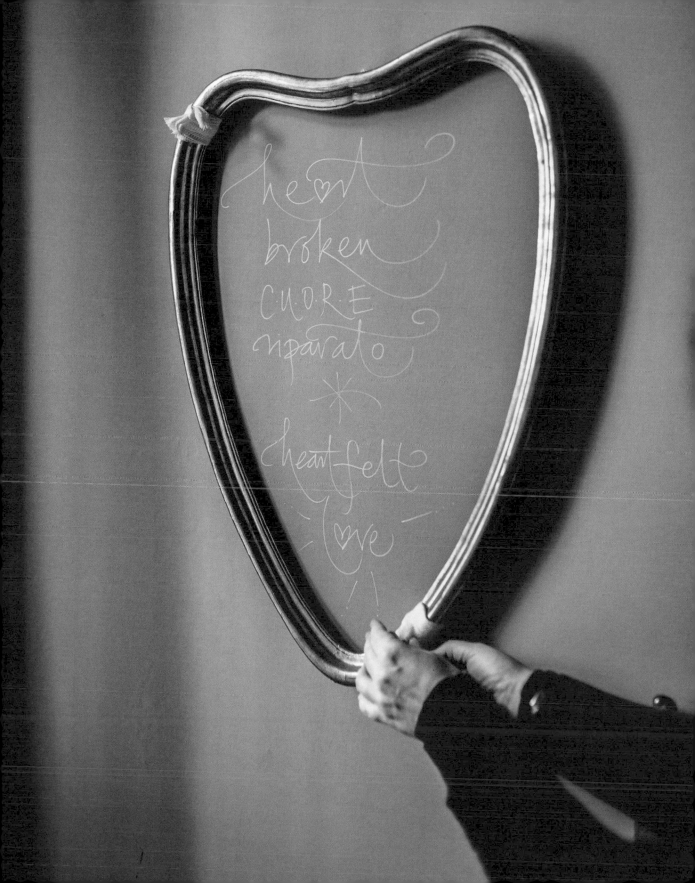

CREATIVITY IS INTELLIGENCE HAVING FUN

Ready to make a beautiful mess?!

Come back into contact with what and how you write, as an expression of you. It's never too late to embrace this artistic endeavour. Allow yourself to be a beginner, which takes courage and can get messy. Literally.

Let's spill some ink…

Throughout this book I have written titles and quotations using a pointed pen, with a flexible nib dipped into a bottle of ink. You will get to play with this later. For these exercises and alphabet letterforms to come I will use a simple cartridge pen like you.

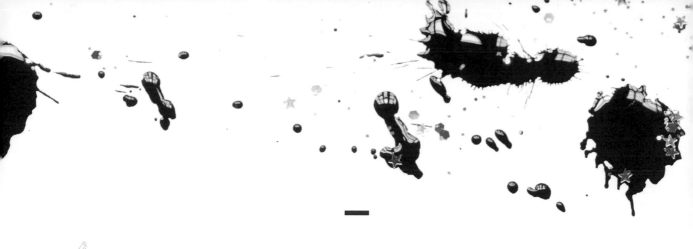

You may feel apprehensive about writing in pen on these pages. Here are some exercises to take away the fear of making a mess. Put a new cartridge in your ink pen, then shake it with the cap off to get the ink flowing and create your own splatter masterpiece.

splash » BETTER AN 'OOPS' THAN A 'WHAT IF...'

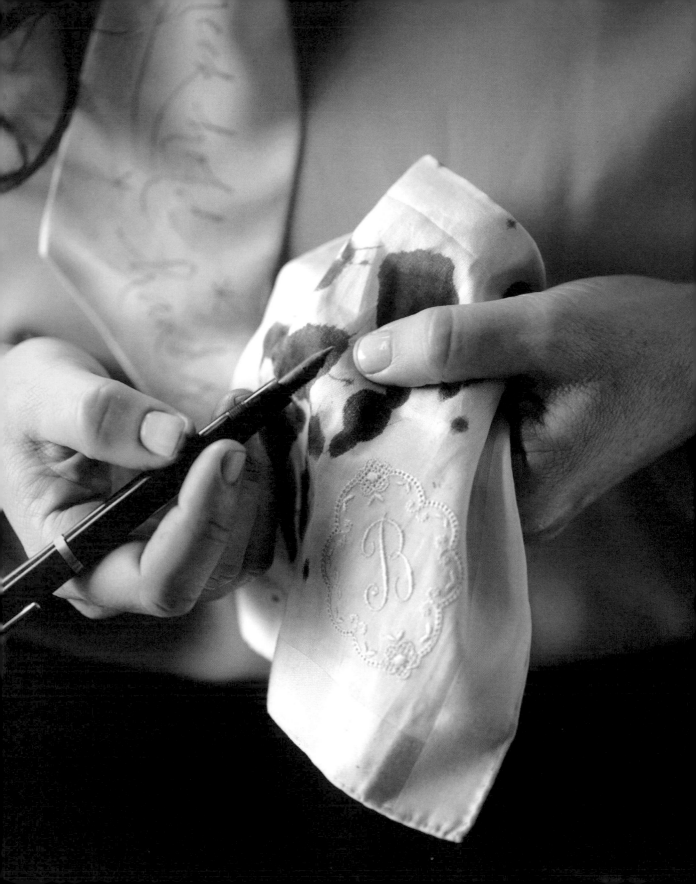

 Rorschach ,, YOUR OWN PERCEPTIONS OF INK BLOTS

—

1
Fold this page in half along the dotted line
and open again.

2
Shake the pen with the cap off
on this page until you get lots of blots.

3
Fold the page, press down and see what
symmetrical ink blots appear. Leave to dry.

THIS IS A SIDE OF YOURSELF YOU
PROBABLY DIDN'T KNOW EXISTED!

Going back to the beginning is often harder than just continuing along your path. Imagine going to a yoga class for the first time – you don't have much self-awareness or control over your movements. You shake as you try to hold postures, you have no idea what to do about your breathing... but, with time, you become more flexible in mind and body, you grow stronger and you learn to use your breath as a tool for soft strength and for letting go.

Calligraphy is the same. Learning how to be present and master flaws as well as making them your own will give you a foundation to build your unique style of modern script. It's amazing what happens when you eventually realise perfect is overrated and you are already enough. Trying something different is a challenge – and oodles of fun when that means scooting black ink across a page...

hand writing

Each of us carries a unique calligraphic style made up of component parts. Let's look at your hand writing, this 'being' we carry inside of us:

What's your slant? Where do you lean towards? Does it change depending on your mood? If your slant is upright, play with a different angle – backwards and forwards (in graphology slanting forward signifies being open to new experiences – well, you're here!). If you usually write slanted, what does it feel to write straight and upwards?

WHAT'S THE SHAPE OF YOUR LETTERS?

Rounded (are you creative and artistic?)

Pointed (are you intense and curious?)

WHAT'S THE SPACING BETWEEN YOUR LETTERS LIKE?

This is the amount of 'air' you give each letter when composing a word – mine are cosy and live closely together, curled up like a cat.

Imagine your letters were tourists. How would they travel:
on a rocket to the moon? Or on the back of a snail?

Write the name of your favourite holiday destination. Begin quickly,
as though you are zooming to get there, then slow your lettering
down, as if you have arrived and are starting to relax...

It all starts with ink, fluidity, making our mark. What places or moments in your life have you felt most free and in the flow – a favourite spot in nature maybe? Think of a favourite shape, squiggle or symbol that embodies f l o w and means something to you.

Perhaps I'll have this squiggle inked as a tattoo – what would yours be?

Now for something more rigid. Write some words all in capitals – vertically, as they do in many oriental languages...

INKSPIRATION

The action or power of moving the intellect or emotions, a divine influence exerted upon the mind and soul.

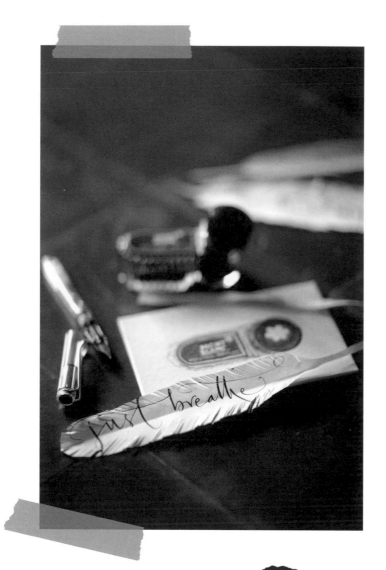

inhale the present

INKSPIRED

The feeling that you want to
do something and can do it –
a creative impulse to produce
inky writings and words.

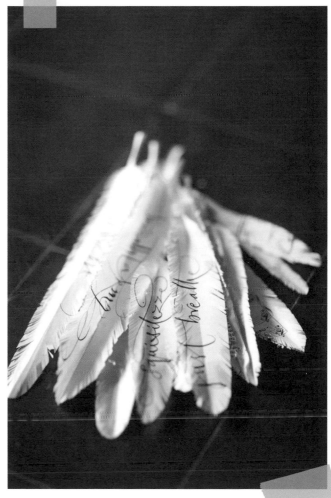

exhale the past

FEATHERINK

Feathering with ink is
a warm-up exercise to get
the hand, arm and wrist
all moving without worrying
about letterforms just yet.

To begin with, you think
about what you are doing,
until you eventually lose
yourself in the repetition.

Trace over the line marks
opposite, then fill pages and
pages with ever faster similar
marks of your own making.

The pleasure of mindful
consciousness continues even as
you eventually let go.

Let it happen.

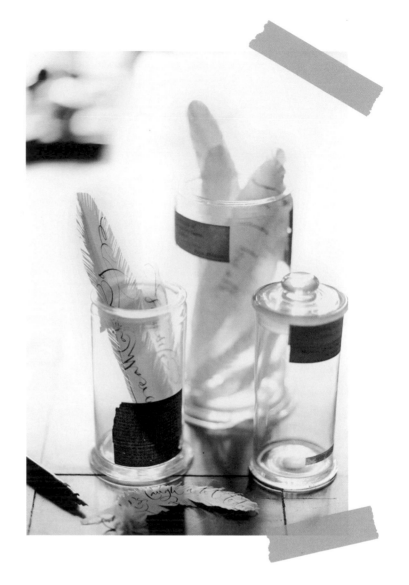

**DO THIS LISTENING TO YOUR
FAVOURITE MUSIC, WITH LIGHT
STREAMING IN FROM THE WINDOW OR
A CANDLE ILLUMINATING THE WAY.**

**REMEMBER TO BREATHE.
AND TO SMILE, AND TO ENJOY.**

Make some fast line marks from the bottom upwards.

Now put them together in a series of top marks and bottom marks that meet in the middle.

Same again with more of a curve.

Put them together again – closed... and open.

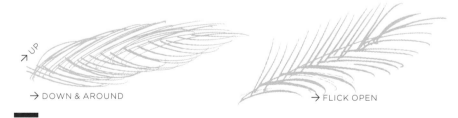

Now make a feathery arrow, ready to move forwards...

featherlight

Play with light and heavy strokes of your pen to create your own kind of feathers.

Jump and you will learn to unfold your wings as you fall

perfectly imperfect *perfectly imperfect* *perfectly imperfect* *perfectly imperfect* *perfectly imperfect*

Fill this space, either repeating the same words or with a continuous stream of consciousness with no punctuation. Try not to lift your pen off the page. Get into a repetitive rhythm, with no judgement about what and how you are writing – just let it f l o w.

RELAX – NOTHING IS UNDER CONTROL...

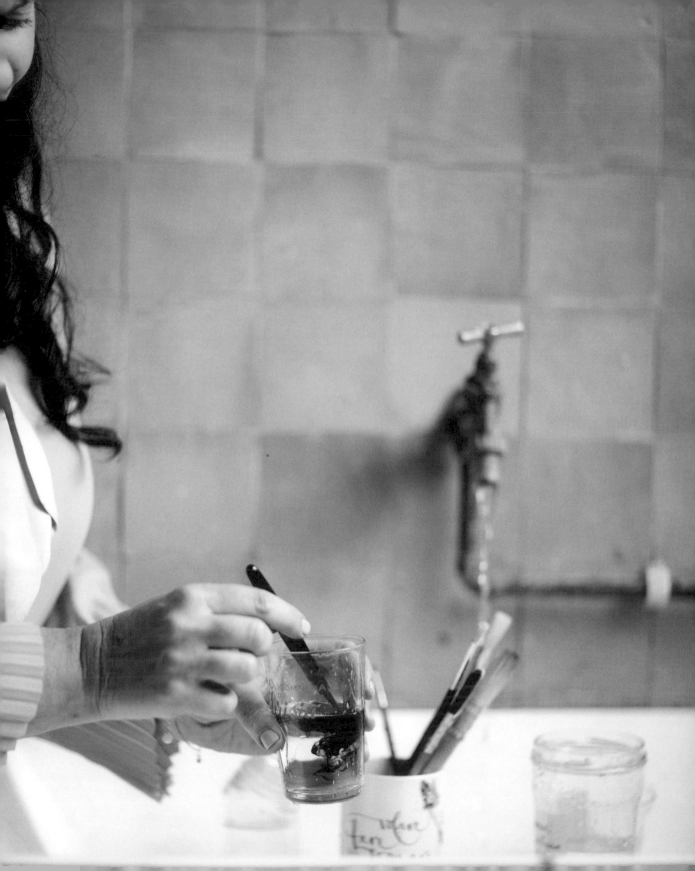

It is said that Leonardo da Vinci could simultaneously sketch with one hand and write with the other. Wowee. Playfully looking at inkiness in different ways changes our perspective of how and what we write. Letting go is necessary in order to create space for newness.

Now we are moving onto using the ink pen to explore different ways of writing calligraphic letter shapes in order to nurture confidence and to move onwards and upwards, slowly but surely...

LET IT ALL GO...
SEE WHAT STAYS

An important aspect when beginning to write is intention. You are taking the time to be here, creating space and awareness to do this for yourself. Honour it. Sitting with the correct posture will help your writing to flow better and make it easier to connect with what you are trying to achieve.

CONNECTING

BEGIN — Sit up straight with both feet on the floor. Feel a grounded connection to the earth.

NOTICE — Look at the orientation of your body to the paper – try to remain sitting straight, rotating the page to whatever angle feels comfortable for you.

SPACE — Relax your shoulders, rolling them back and down.

SEE — Move your head from side to side. Now look forward and down, focused.

PERCH — Sit close to the edge of your chair, which will help to keep your back straight.

POISE — Shake your arms and lay them gently down, with the forearm of your writing hand poised to glide over the table at chest level.

♥ From heart to hand.

THINK Hold your pen mindfully; it is an extension of you.

SIGH Remember to breathe.

YES Relax, smile inwardly, ready to take a leap into doing and being.

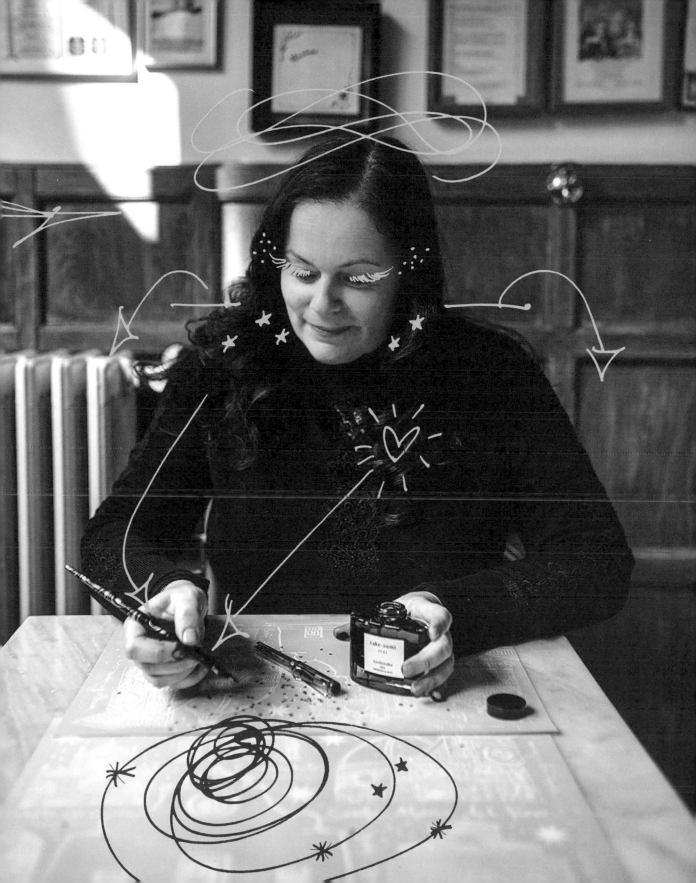

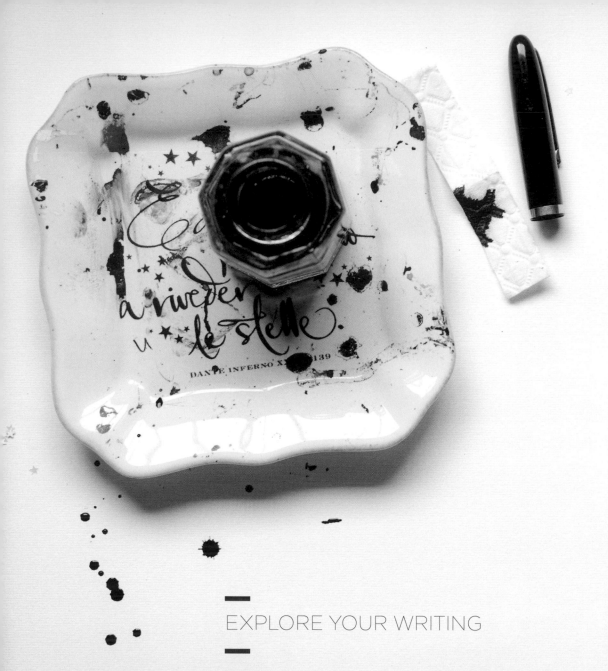

EXPLORE YOUR WRITING

Gather together a variety of pens to try out. My favourites have always been vintage inkpens found in antique markets – their nibs are already softened with all the stories they have written. I like to imagine that a pen remembers every word, it reads what you are thinking and saying...

There are so many different letterforms to discover – from classical script styles to type to street art and graffiti. There are many tutorials and 'how to' guides out there to achieve all these different kinds of lettering, many of which are quite prescriptive. The truth is, the process should be less about them and more about you. The way your personal calligraphy style will develop is dependent on you and how you approach the process.

Shoot for the moon – even if you miss you'll land among the stars.

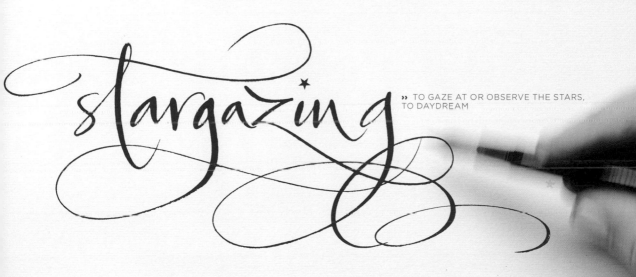

stargazing » TO GAZE AT OR OBSERVE THE STARS, TO DAYDREAM

Remember – if it doesn't challenge you, it doesn't change you, and here we are looking to evolve. With patience and practice you will hone your thinking skills, build your hand and muscle memory, and above all train your eye to look, notice and improve. See the marks you make, the spaces, the balance, the direction: when you change the way you look at things, the things you look at change.

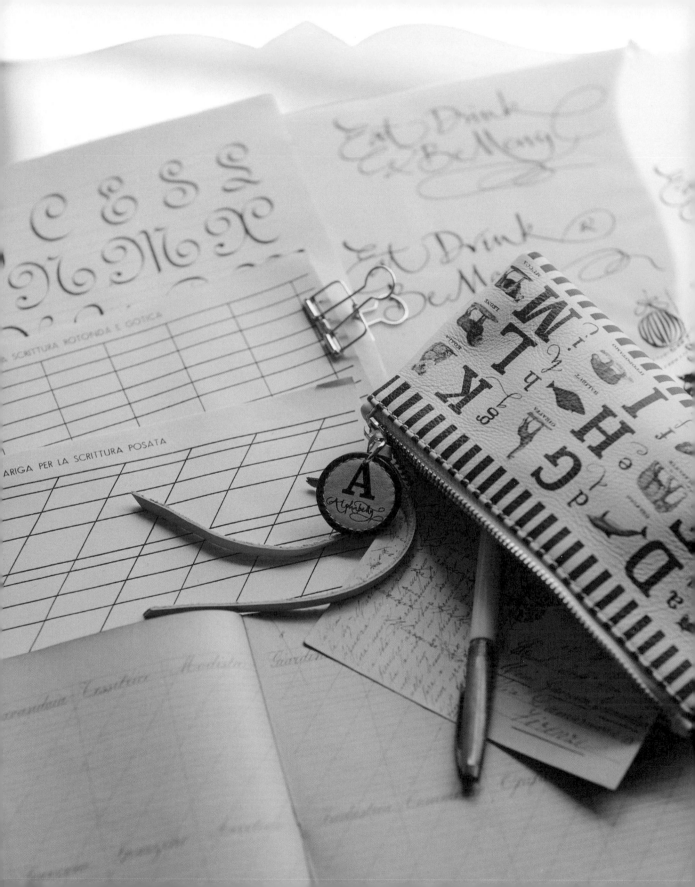

The Alphabetty is a collection of letters that carry my calligraphic style. This is unique to me, and as you adapt the alphabet to nurture your own hand, the letters will become unique and true to you.

Up until the Renaissance in the 1400s, penmanship essentially used no loops or joins. This began to change when Italic penmanship became more popular (in this instance, 'Italic' means 'in the style of ancient Italy', not the slanted type we call *italic* today). In order to enhance writing speed, the letters in the handwriting of the Renaissance were joined, with fewer pen lifts. Cursive (meaning writing joined together in a flowing manner, especially to make writing faster) comes from the Medieval Latin *cursivus*, which literally means to run or hasten.

Calligraphy is having a modern renaissance of its own. Although I revere classical script styles, where the aim is uniformity and perfection, my personal style is looser, more spontaneous and constantly changing. 'Modern Calligraphy' as we know it today is cursive and almost always slanted, taking the lead from American forms of writing, although my own calligraphy is straight rather than slanted. I am thrilled there is a return to the art of handwriting as an act of self-exploration and generosity of spirit, wishing to share thoughts and ideas and love notes through a physical missive.

THE BEAUTY IS THERE IS NO RIGHT OR WRONG WHEN DEVELOPING YOUR OWN CONTEMPORARY STYLE, IT'S ABOUT BEING OPEN-MINDED AND TRYING OUT DIFFERENT WAYS OF WRITING.

You do need to embrace some basic forms before you can set them free with a flamboyant curl, so try out different fountain or cartridge pens until you find one that feels right to you. I recommend you choose one where the ink flows smoothly with a light hand-held grip and light touch on the paper so as to minimise muscle fatigue and cramping. Like everything, we need to exercise muscles to become better.

» VARIETY IS GOOD FOR THE SOUL AND THERE ARE LOTS OF DIFFERENT WAYS OF FORMING LETTERS

← *A printed leather 'just inkcase' pen holder, a collaboration with Edition Poshette, carries my Alphabetty A to Z.*

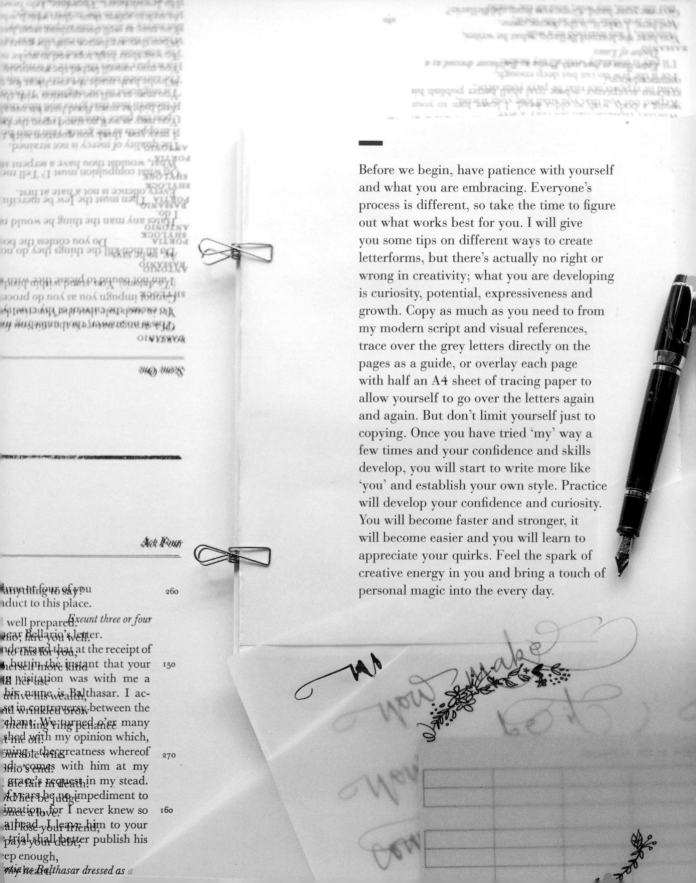

Before we begin, have patience with yourself and what you are embracing. Everyone's process is different, so take the time to figure out what works best for you. I will give you some tips on different ways to create letterforms, but there's actually no right or wrong in creativity; what you are developing is curiosity, potential, expressiveness and growth. Copy as much as you need to from my modern script and visual references, trace over the grey letters directly on the pages as a guide, or overlay each page with half an A4 sheet of tracing paper to allow yourself to go over the letters again and again. But don't limit yourself just to copying. Once you have tried 'my' way a few times and your confidence and skills develop, you will start to write more like 'you' and establish your own style. Practice will develop your confidence and curiosity. You will become faster and stronger, it will become easier and you will learn to appreciate your quirks. Feel the spark of creative energy in you and bring a touch of personal magic into the every day.

WRITING IS
THINKING THROUGH
YOUR FINGERTIPS

The creative process is the inspiration. You are here, you are on your way. You've been called to adventure. Use the shape of my letters as a base to introduce variations into your own writing – they will feel forced to begin with as they are a new way of thinking through your fingertips, and your mind will want you to continue doing things as you have always done them.

MOVING FORWARDS WILL BE SO MUCH MORE ABOUT LETTING GO THAN ABOUT CONTROL.

You will discover along the journey that you can do something you didn't realise you were capable of, and the more you do it, the more you can do it. Practice doesn't make perfect, it makes progress – at your own pace, in your own way.

'You are
your own teacher.

Looking for teachers
can't solve
your own doubts.

Investigate yourself
to find the truth –
inside, not outside.

Knowing yourself
is most important.

The heart is
the only book worth
reading.'

(Ajahn Chah)

LET'S BEGIN...

MY A TO Z LETTERS ARE NOT ABOUT ACADEMIC PERFECTION, BUT RATHER OPEN YOU UP TO NEW WAYS OF WRITING.
-
LOOK CLOSELY AT MY BLACK LETTER VARIATIONS THROUGHOUT: THEY PROGRESS FROM LINEAR TO MORE WHIMSICAL. MANY MODERN CALLIGRAPHY GUIDES GIVE YOU ARROWS TO SHOW WHERE TO START AND CONTINUE THE LETTER. I OCCASIONALLY GIVE A STAR (★) AS AN INDICATION OF A STARTING POINT, GIVING YOU THE FREEDOM TO WORK OUT WHATEVER FEELS BEST FOR YOU.
-
TRACE OVER THE GREY VERSIONS, THEN REPEAT EACH ONE ON EACH PAGE, CONTINUING ON SEPARATE PIECES OF PAPER UNTIL THEY BECOME MORE FAMILIAR TO YOU...

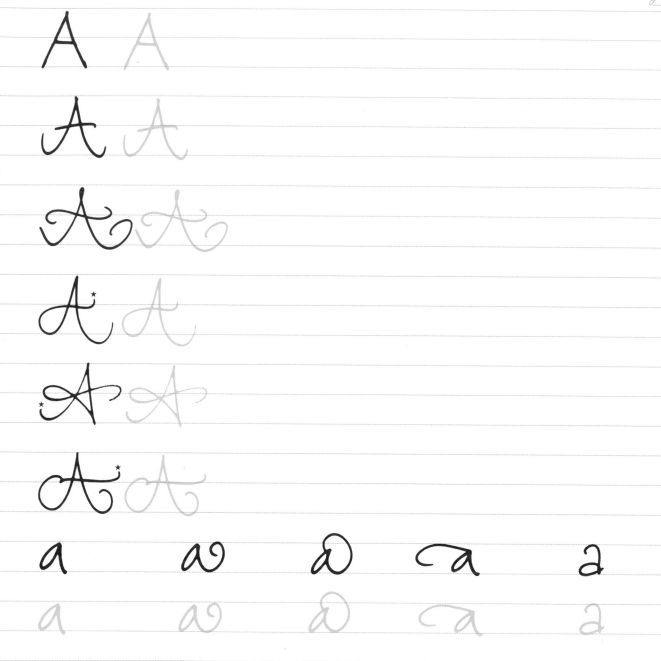

ALPHA = THE FIRST LETTER OF THE GREEK ALPHABET TRANSLITERATED AS 'A'
ASTRA = THE FIRST (TYPICALLY THE BRIGHTEST) STAR IN A CONSTELLATION

B B

THESE TWO
LETTERS, **B** & **P**,
HAVE LOTS OF
SIMILARITIES
IN THEIR
ANATOMY

P P

B B

P P

B B

P P

B B

P P

B B

P P

b b

P P

b b

P P

b b

P P

b b

P P

C C

E E

C C

E E

C C

E E

C C

E E

C C

E E

C C

E E

c c

e e

c c

e e

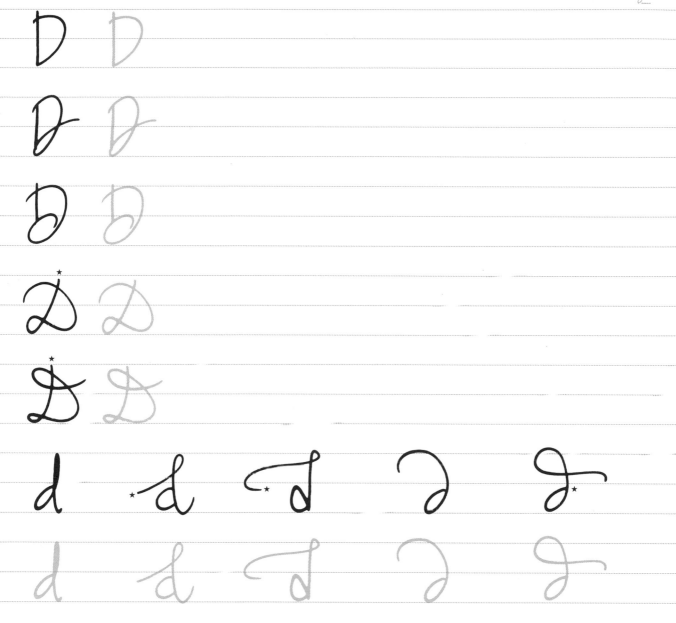

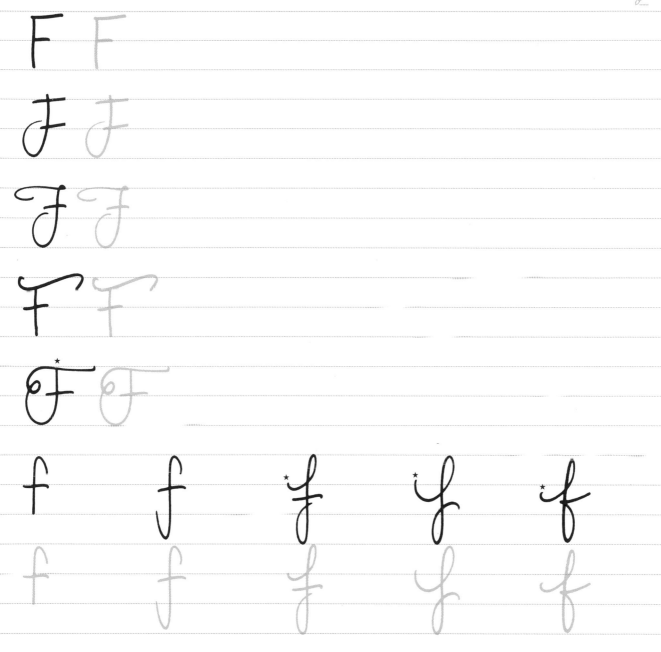

G G g g

G G g g

G G g g

G G g g

G G g g

G G g g

G G g g

↗ PLAYING WITH THE LOWER DESCENDER OF THE 'G' IS ONE OF MY FAVOURITE TYPOGRAPHICAL EXPLORATIONS

H H K K

H H K K

H H K K

H H K K

h h k k

h h k k

h h k k

h h k k

Keep thinking of letters as shapes to be played with. See what structures of letterforms appeal to you as you start to develop an array of ways of writing the same letter.

Keep your hand warmed up in its looseness by copying over these loopy exercises below, repeating them freehand, then seeing if you can manage to trace over the complete phrase.

There are so many amazingly coloured inks around, but I do love a deep, dark, inky black!

'INK: THE BLACK LIQUOR WITH WHICH MEN WRITE' – SAMUEL JOHNSON'S *A DICTIONARY OF THE ENGLISH LANGUAGE*, 1755. FROM THE OLD FRENCH *ENCRE*, MEANING 'DARK WRITING FLUID' (12C.), ORIGINALLY *ENCA*, FROM THE LATE LATIN *ENCAUSTUM*, MEANING 'TO BURN IN'. THE USUAL WORD FOR 'INK' IN LATIN WAS *ATRAMENTUM*, WHICH LITERALLY MEANS 'ANYTHING THAT SERVES TO DYE BLACK', AND COMES FROM THE WORD *ATER*, MEANING 'BLACK'. THE GREEK WORD WAS *MELAN*, AND THE OLD ENGLISH WORD WAS BLÆC, AGAIN BOTH MEANING 'BLACK.' THE SAME PATTERN CAN BE FOUND IN THE SWEDISH (BLÄK) AND DANISH (BLÆK).

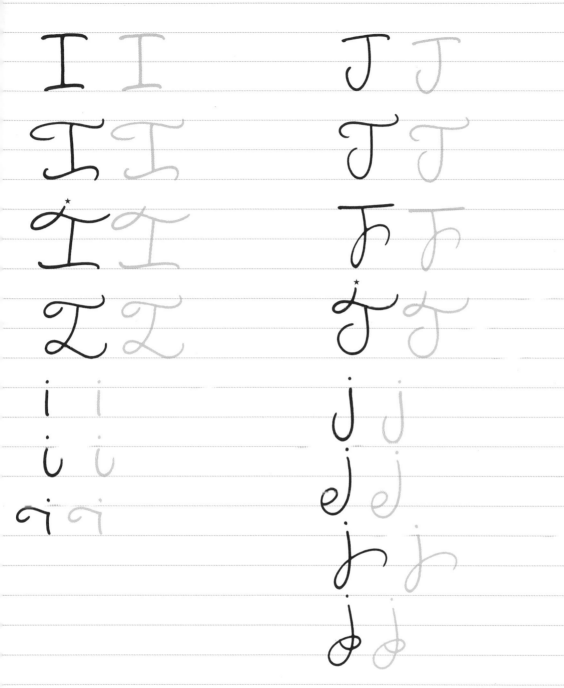

THE **DOT** OVER THE LOWER CASE I & J IS CALLED A 'TITTLE' OR SUPERSCRIPT DOT.

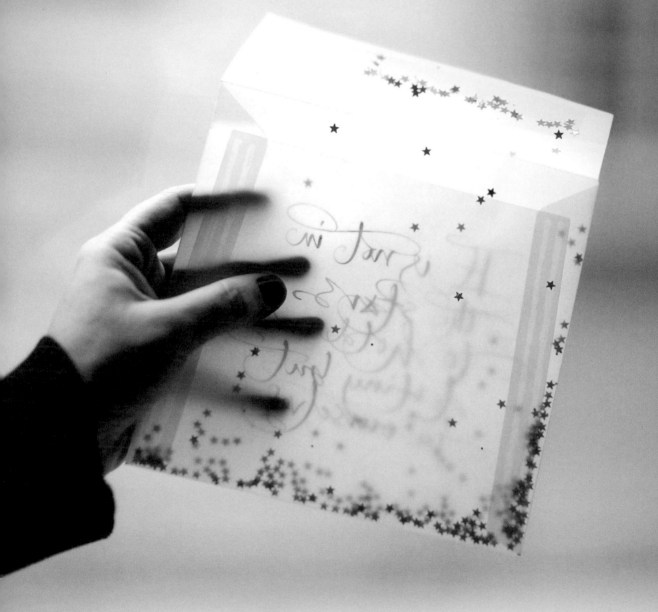

L L

L L

L L

L L

Le Le

L L

Le Le

| | U ll

AN **ALPHABET** IS A WRITING SYSTEM, A LIST OF SYMBOLS FOR WRITING. THE BASIC SYMBOLS IN AN ALPHABET
ARE CALLED LETTERS, WHERE EACH LETTER IS A SYMBOL FOR A SOUND OR RELATED SOUNDS.
TO MAKE THE ALPHABET WORK BETTER, MORE SIGNS ASSIST THE READER: PUNCTUATION MARKS, SPACES, ETC.

M M m m

M M m m

M M m m

M M m m

M M m m

M M

M M

mmmmmmmmmmmmmmmm n

4000 YEARS AGO, THE EGYPTIANS DREW A WAVY LINE AS THEIR HIEROGLYPHIC SYMBOL FOR 'WATER'. THE SYMBOL
WAS SIMPLIFIED BY THE PHOENICIANS INTO AN '**M**' SHAPE, ADOPTED AS A LETTER FOR THEIR ALPHABET AND NAMED
AFTER THEIR WORD FOR WATER, *MEM*.

N N

N N

N N

N N

N N

N N

n n

n n

n n

REMEMBER TO TAKE
A '**JAZZ HANDS**'
BREAK, OPENING
AND CLOSING YOUR
WRITING HAND TO
PREVENT ACHING
OR CRAMPING…

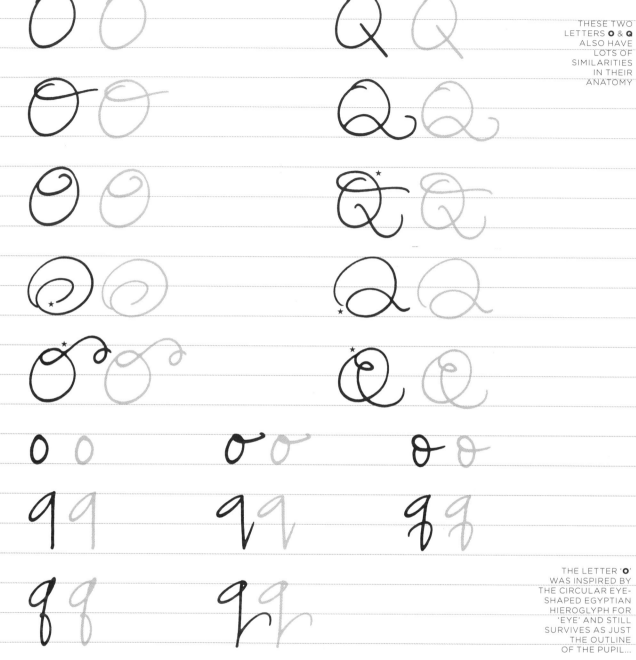

THESE TWO
LETTERS **O** & **Q**
ALSO HAVE
LOTS OF
SIMILARITIES
IN THEIR
ANATOMY

THE LETTER '**O**'
WAS INSPIRED BY
THE CIRCULAR EYE-
SHAPED EGYPTIAN
HIEROGLYPH FOR
'EYE' AND STILL
SURVIVES AS JUST
THE OUTLINE
OF THE PUPIL...

**EYE SEE YOU!!
KEEP GOING...**

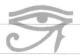

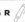

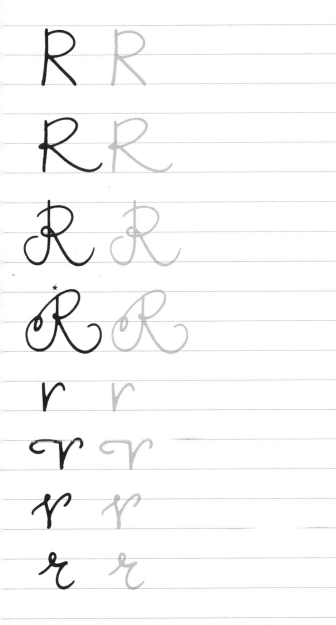

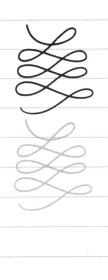

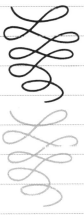

Look at the amazing swooshes on the 'E', 'b' and 'R', which stands for *'Regina'*, meaning Queen in Latin.

espresso

Stop for a moment – time for a coffee break! And some curly wurly sssssss exercises:

'DOUBLE **U**'
ONLY BECAME
A UNIQUE LETTER
– **W** – IN 1700!

THE '**X**' WE USE TO SEAL MESSAGES WITH A KISS DATES BACK TO THE MIDDLE AGES WHEN A CHRISTIAN CROSS WAS DRAWN ON DOCUMENTS TO SIGNIFY FAITH AND HONESTY, FOLLOWING THE KISS THAT WAS PLACED ON JESUS'S FEET AT THE CROSS.

THE AMPERSAND IS A LOGOGRAM '**&**', REPRESENTING THE WORD 'AND'. THE SYMBOL WAS OFTEN INCLUDED AT THE END OF THE ALPHABET AS A 27TH LETTER AND, WHEN IT WAS RECITED IN ENGLISH SCHOOLS, THE CHILDREN WOULD SAY: '...X, Y, Z AND PER SE & (AND)'. THE USE OF 'PER SE' WHICH MEANS 'BY ITSELF', WAS TO AVOID THE CONFUSION OF SAYING 'AND AND'. OVER TIME, THE PHRASE BECAME SHORTENED TO 'AMPERSAND'. THE SYMBOL ITSELF IS A LIGATURE (THE JOINING OF TWO OR MORE LETTERS) AND COMES FROM THE LETTERS 'ET', LATIN FOR 'AND'.

I LOVE USING IT WHENEVER I NEED TO INDICATE A CLOSER COLLABORATION THAN JUST AN 'AND'...

ROMAN NUMERALS WERE EXPRESSED BY LETTERS OF THE ALPHABET:

I	V	X	L	C	D	M
1	5	10	50	100	500	1000

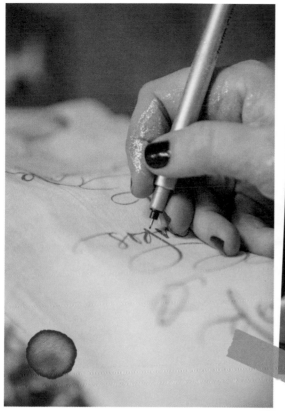

Hopefully you are now starting to feel a looseness in your writing. It will take some time to achieve a more relaxed fluidity, but by continuing to practise and replicate these different letter shapes you will begin to visualise alternative letterforms to bring into your own style. Look at changing angles, widths, spaces, heights, flourishes – and also at using different pens, from biros chewed at the top to felt tips, thin markers to rollerballs. Notice how each one feels different as you write and gives a particular look to your writing.

When you put all the letters of the alphabet together they can resemble one long single word...

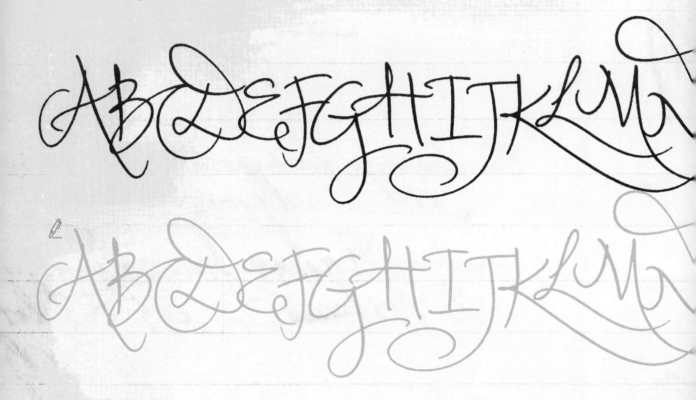

PQRSTUVWXYZ

Now let's play with putting letters together, practising some twirly swirls and wordsmithing with flourishes... every letter is an exciting opportunity for a new word shape to happen.

La frase migliore al momento giusto
è sempre e solo quella che sgorga dal
vostro cuore, che esprime quello
che realmente sentite e che viene
fatta considerando la profonda
conoscenza che avete di chi vi
sta davanti, della sua indole e
della sua sensibilità. È infatti
certo che l'atmosfera in questo
storico momento sarà unica,
indimenticabile, coinvolgente
solo ed esclusivamente se sarà
"vera" "vostra" "personale."

★ ALPHABETTER

Some letters, when put together to form words, allow for moments of playful flourishes and fluttering opportunities:

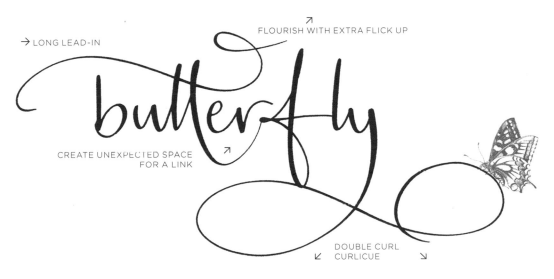

→ LONG LEAD-IN

↗ FLOURISH WITH EXTRA FLICK UP

CREATE UNEXPECTED SPACE FOR A LINK ↗

DOUBLE CURL CURLICUE ↙ ↓

Now practise flourishes!

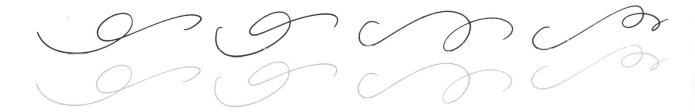

Here are some ideas of where to add flourishes to emphasise a word elegantly and ornately. At the beginning or when you end a word is a dramatic moment to add an embellishment:

Mid-word there are opportunities at the top of an ascending stem, for example:

and also at the bottom of a descending tail:

Remember also to always think of the relationship between letters, words and an entire phrase:

These are some of my favourite letters as they allow swashes in the crossbar and descenders:

TAKING FLIGHT

Here we will look at developing your repertoire!
Let's put butterflies in their natural habitat and explore calligraphic ways of playing with nature:

nature

ADD LEAFY TOUCHES

**ROTATE THE PAGE
AS YOU WRITE,
CREATING THE SHAPE
OF A BUTTERFLY**

**TRACK THE PATH
OF FLUTTERING WINGS
USING WORDS**

butterfly farfalla papillon sommerfug

joie de vivre

**ENCASE WORDS
IN FLORAL WREATHS**

**GROW WHERE
YOU ARE PLANTED**

SKY HIGH

ILLUSTRATE WORDS

fly

SPREAD your WINGS

LETTER FLUTTERINGLY

la vita e bella

your mind is a

NURTURE YOURSELF

GARDEN

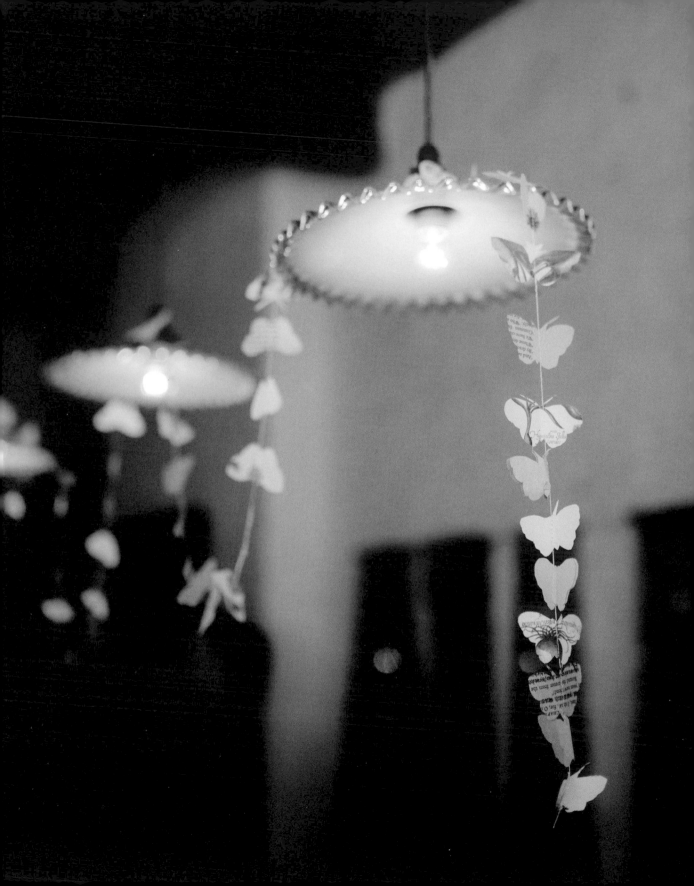

WHAT TO WRITE

In workshops, as people develop their writing style, they sometimes get stuck as to what to write beyond their name when they are urged to venture freely on a blank page.

WHAT YOU WRITE IS AS MUCH A PART OF YOU AS HOW YOU WRITE.

Collecting quotes by favourite artists is a great way to express thoughts and emotions that resonate – as are song lyrics or anything else that is meaningful to you. Another good way to play calligraphically is to write out pangrams. These are phrases that cleverly use all the letters of the alphabet, while still making some sort of sense!

These are fun to write even in languages you do not understand; it's a way of putting words next to each other. Trace over these, then try writing them on a separate page using your own writing quirks which are now evolving:

ENGLISH

the quick brown fox jumps over the lazy dog

ITALIAN ‹‹ SOME SMART PERSON WILL HAVE SPACE, UNWORTHILY

avrà spazio qualche furbo, indeguamente

FRENCH ›› TAKE THIS OLD WHISKY TO THE BLOND JUDGE WHO IS SMOKING

portez ce vieux whisky au juge blond qui fume

GERMAN ›› 'QUICK SCHWYZ!' JURGEN SQUAWKS ZANILY FROM THE PASS

"Fix, Schwyz!" quäkt Jürgen blöd vom Paß

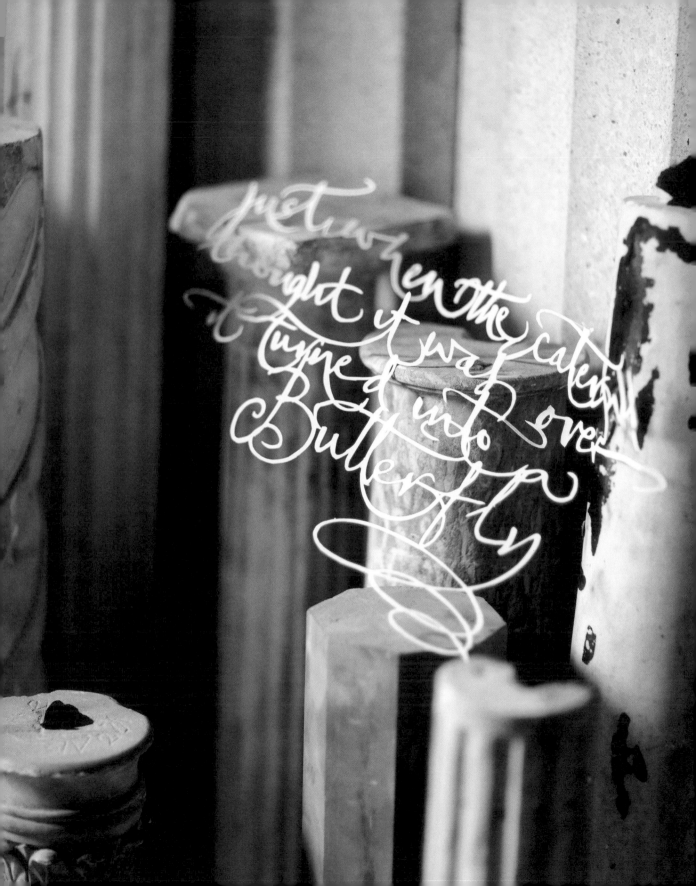

just when the caterpillar thought it was over it turned into a Butterfly

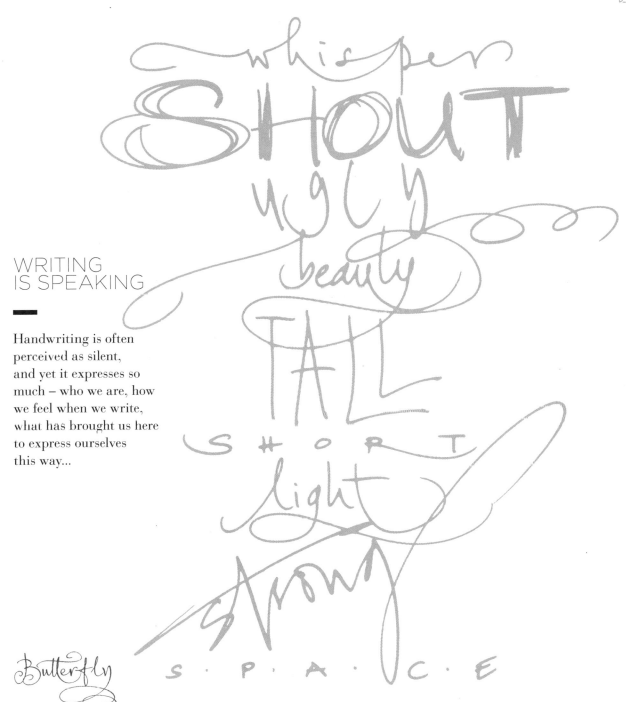

whisper
SHOUT
ugly
beauty
TALL
S H O R T
light
Around
S · P · A · C · E

Butterfly

WRITING
IS SPEAKING

Handwriting is often
perceived as silent,
and yet it expresses so
much – who we are, how
we feel when we write,
what has brought us here
to express ourselves
this way...

← My calligraphy and flourishes transformed
into a scalpel papercut by the talented graffiti
artist and 'writer' David S.

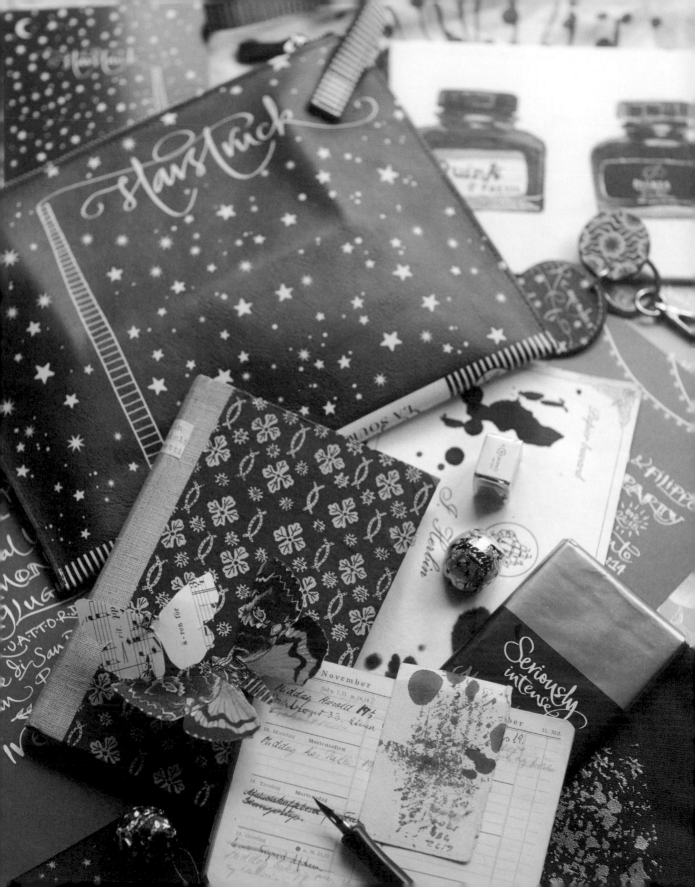

FRESH THINKING

I sometimes like to give writing activities a theme – like the collection of nature wording on pages 106–107, or lists of my favourite things.

Try this project: research the different names given to oil paints used by artists. Some of them are quite mystical and majestic! Choose your favourites and write them out, changing style for each and letting the creative words influence the way you write them. Legibility is not even a factor here, just expressiveness.

Prussian

ultramarine

cobalt

indanthrene

blue *

turquoise

manganese

Be inkspired to try new things and think differently – for yourself! This is one of my favourite quotes. Now write out one of your own, being aware of layout, composition, where letters touch and where there are any opportunities to add your own quirks...

IT'S IN YOUR HANDS

Graphology is the science of analysing handwriting for personality traits. It has been around since the days of Aristotle. Seven key characteristics are considered when looking at a sample of handwriting:

* **SLANT**
* **LETTER SIZE**
* **SPEED**
* **ORGANISATION**
* **PRESSURE**
* **LIGATURE**
* **LETTER SHAPES**

Think about these elements when continuing to develop your own calligraphy.

I have given you lots of variations of letterforms and playful swooshes to experiment with, but now it is time for you not to try to write like *me*, but to write like *you*. Allow your own style to evolve. Put in the time and consideration in order to create a unique style that is representative of you.

Here are a few of my own guidelines for calligraphy (and life) to get you started:

1
ADD QUICK, IMPERFECT CURLICUES AND FLOURISHES TO EVERYTHING YOU WRITE. THEY EMANATE JOY, EVEN ON A POST-IT OR A SHOPPING LIST!

2
LET YOURSELF MAKE MISTAKES. THEY ARE UNIQUE TO YOU, AND THAT IS YOUR POWER.

3
'I TOOK YOUR IDEA AND MADE IT BETTER' – BE INKSPIRED TO CREATE NEW LETTERS, NEW EXPRESSIONS, NEW WAYS OF CONNECTING AND SHARING WORDS. BE GENEROUS WITH THE WAY YOU WRITE, WHERE AND HOW MUCH YOU WRITE. PUT IT OUT THERE.

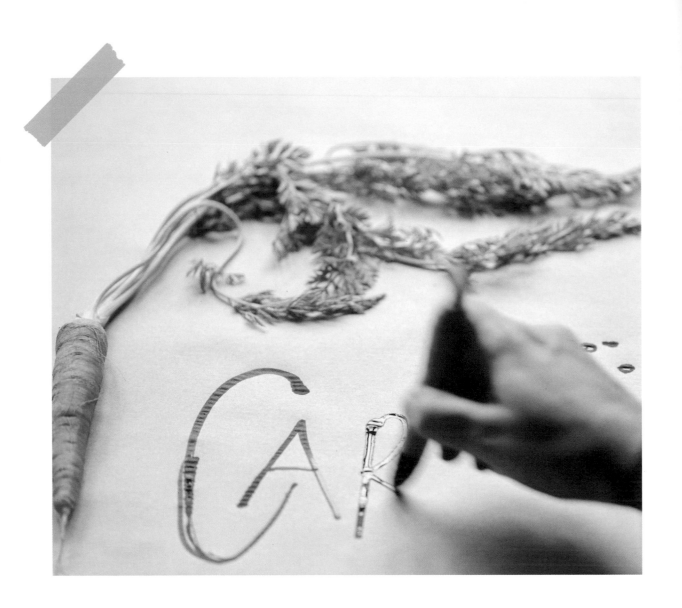

It's time to step away from these pages to see how experimenting with different mediums can help you develop your own style of calligraphy. Using different tools – from markers to white pens to metal nibs – will have an effect on how you write. Above all, they determine the spirit of what and how you write.

✦ CALLIGRAFUN

There's a wealth of calligraphic imagery available everywhere once you begin to search for it. It's always good to look and see, and also discern what works and what doesn't for you. On Instagram, I discovered a playful approach using vegetables to write with to prove that you don't need fancy pens for calligraphy and was inkspired to try it out...

It's true what Einstein said:

Get a bottle of ink, a big roll of kraft paper and a selection of vegetables. Even funny-looking ones!

A carrot looks brilliant half-dipped in black ink and writes with a surprisingly fine, hard tip...

Creativity is contagious, pass it on

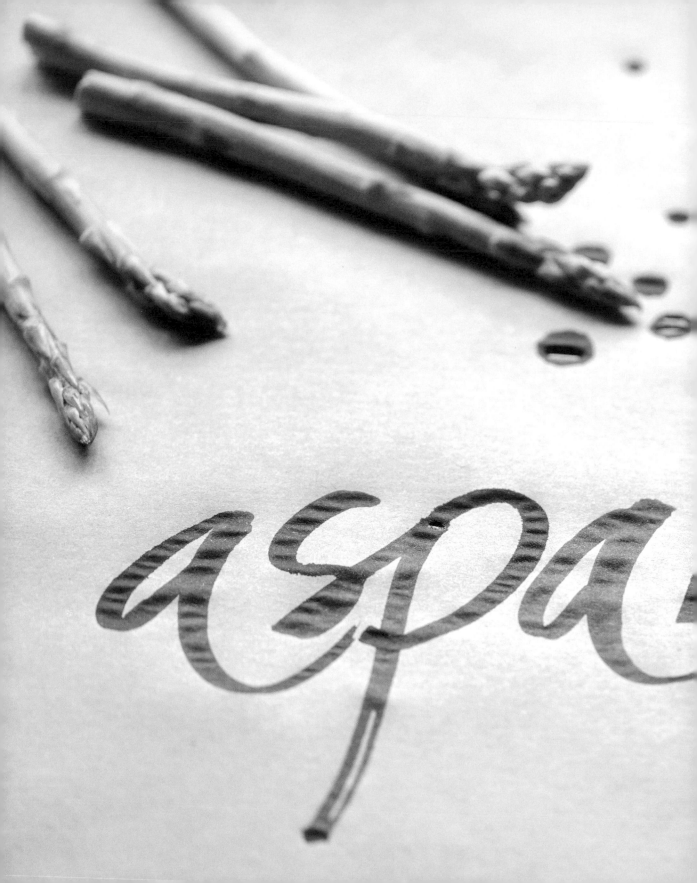

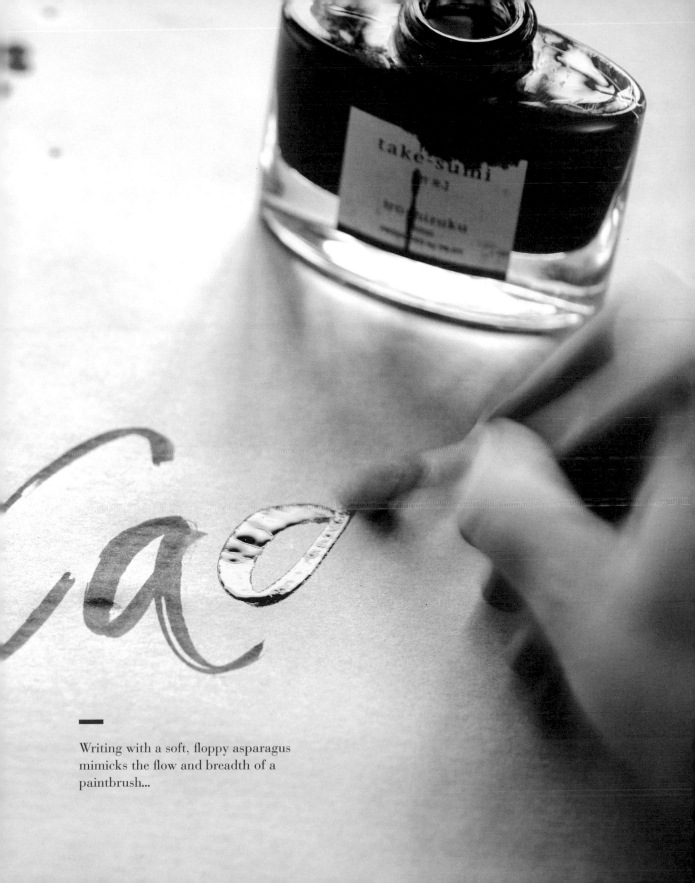

Writing with a soft, floppy asparagus
mimicks the flow and breadth of a
paintbrush...

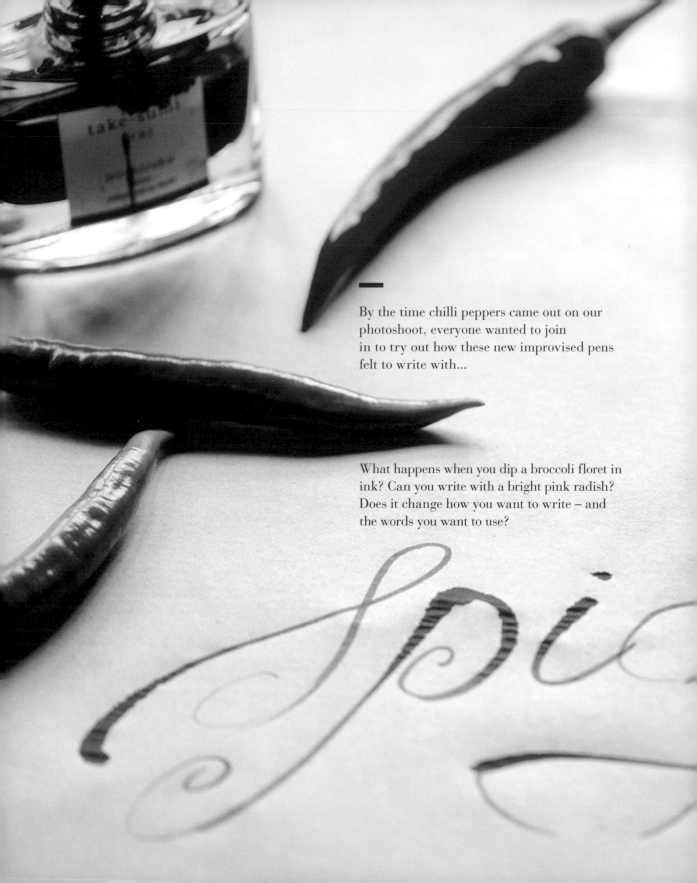

By the time chilli peppers came out on our
photoshoot, everyone wanted to join
in to try out how these new improvised pens
felt to write with...

What happens when you dip a broccoli floret in
ink? Can you write with a bright pink radish?
Does it change how you want to write – and
the words you want to use?

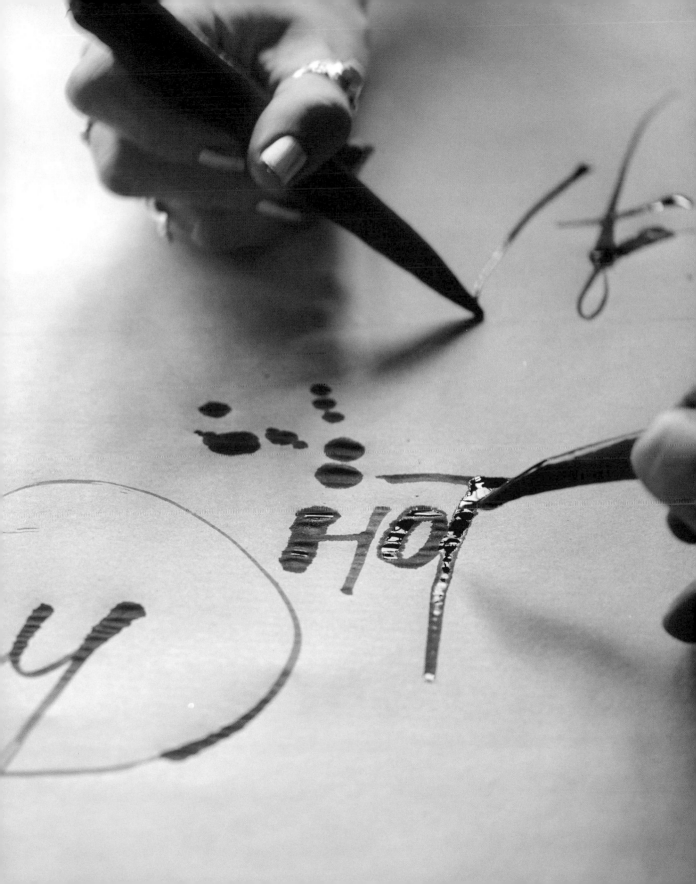

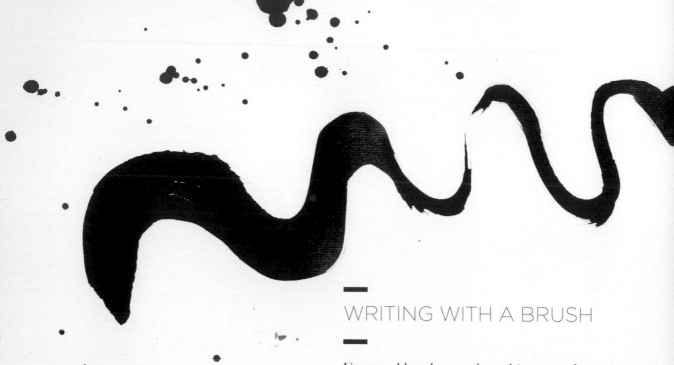

WRITING WITH A BRUSH

Use a real brush – maybe a thin one and a larger round or flat one. Dip into a wide bottle of ink and have a play on large sheets of thick paper.

It will feel VERY different to move the puddles of ink around and create your letterforms with a brush. The more pressure you apply, the more the bristles widen and the thicker the line. If you give it a light flick of the wrist, the letters will be thinner and lighter.

magic in the making

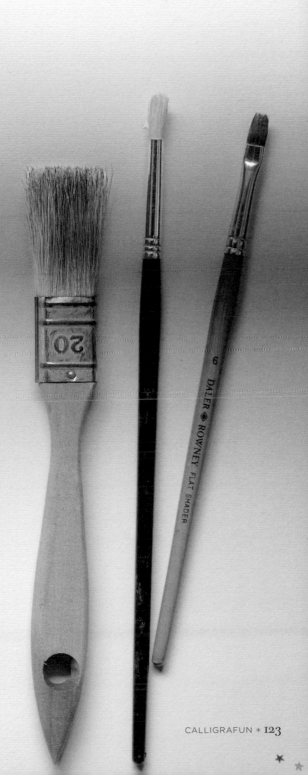

I have always loved the sound of a pen nib scratching as it writes, but here you get swooshes and drips. And, hopefully, marvellous splats! If you enjoy the freedom this gives you, then see how it feels to write with a brush lettering pen, which is all the rage of late. A brush pen is a marker that has a very tapered, brush-like end without bristles. The appeal of this form of pen is that it mimics the look and feel of a real brush, where the width of the stroke line changes with pressure, and it comes in oodles of colourways.

The best way to use brush-pen calligraphy is to write your words relatively large in order to enjoy the full effect of the contrast between wide and thin strokes.

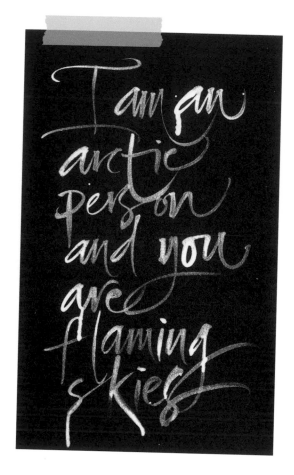

BLEACHED OUT

Now play with this – but BE CAREFUL!

Firstly because of the wow factor, secondly because I am asking you to try writing with bleach.

Bleach corrodes metal, so don't dip your pen nib in, but try it with a real bristle brush. Wear an apron and don't splash it anywhere near your eyes.

Bleach fades colours, so try writing with it neat, or add just a dash of water to remove its viscosity. Use it on coloured papers and watch the effects.

I love writing with it on black paper – depending on the intensity of the bleach you get this amazing luminescence...

Keep exploring and experimenting with the uncontrolled side of writing, letting things happen... even the tiny brush of a nail polish can be intriguing to write with!

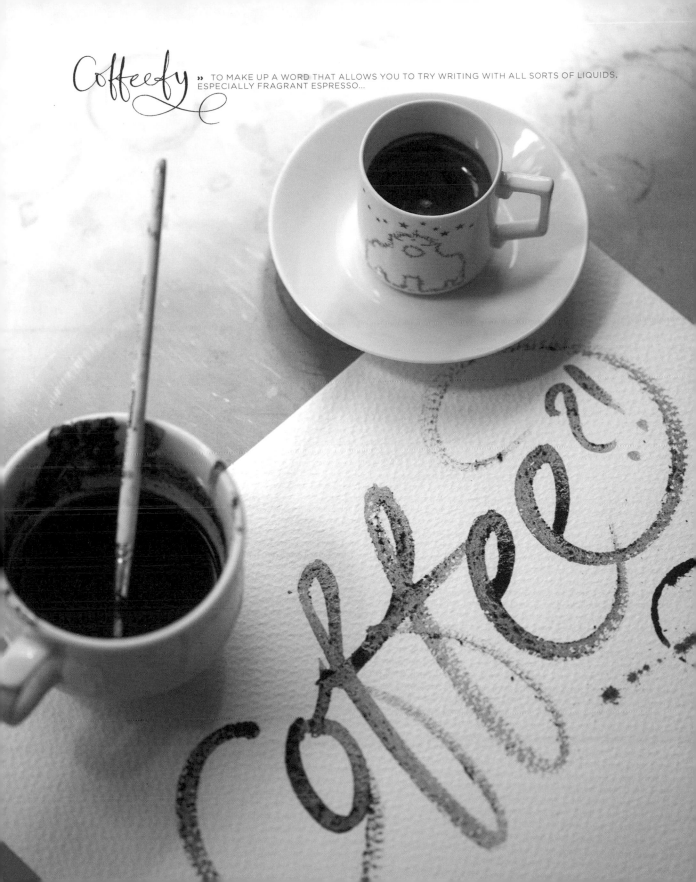

Coffeefy » TO MAKE UP A WORD THAT ALLOWS YOU TO TRY WRITING WITH ALL SORTS OF LIQUIDS, ESPECIALLY FRAGRANT ESPRESSO...

The introduction to this book was written by the superlative Mara Zepeda. For some time before we met, I had followed her work online through her modern calligraphy studio, Neither Snow. I loved the dancing lightness of her slanted writing, often transformed into the most poetic tattoos. So it felt particularly serendipitous when we met in Florence. Mara introduced me to pointed pen, and my vision of modern calligraphy broadened and grew. During her months in Florence we taught our first calligraphy workshops together and collaborated on projects, constantly inspiring one another.

POINTED-PEN CALLIGRAPHY

Mara would enthrall me with her tales of her time studying modern calligraphy at Reed College, a small liberal arts school in the Pacific Northwest of the USA that had a reputation for independent thinking, rigorous study and an unparalleled calligraphy programme. Steve Jobs, the co-founder of Apple, attended Reed College for a brief time and spoke about how studying calligraphy there influenced his mindset: 'Throughout the campus every poster, every label on every drawer was beautifully hand calligraphed. I learned about serif and sans-serif typefaces, about varying the amount of space between different letter combinations, about what makes great typography great. It was beautiful, historical, artistically subtle in a way that science can't capture, and I found it fascinating... 10 years later, when we were designing the first Macintosh computer, it all came back to me. And we designed it all into the Mac. It was the first computer with beautiful typography.' In fact, the very first Macintosh logo was drawn with a calligraphy brush!

I have asked Mara to introduce us to pointed-pen calligraphy over the next few pages. You will see her writing style is divergent to mine – very slanted with lots of differences in light and heavy strokes, thanks to the pressure of the nib. I adore the way her letters bounce dynamically, transmitting her energy. The emotion so prevalent in her calligraphy practice is empowering. She has inkspired me to use the strength of writing, in every way, in all I do.

y awakens
youl to act. DANTE

THE WONDERS OF POINTED-PEN CALLIGRAPHY

Pointed-pen calligraphy is wonderful for many reasons. First, it isn't all that far off from the writing instruments we use in our everyday lives: pencils and ballpoint pens are, in essence, pointy writing instruments. Once they master the basics, new calligraphy students can dive right in – literally, into an ink bottle to dip the nib in – and start exploring.

Second, mastering pointed pen largely comes down to figuring out our own writing style (the slant, shape, speed, spacing) and then experimenting by applying pressure to the nib. And this pressure is such a fun vehicle for the emotion we might be feeling that day! For example, light, consistent pressure calls to mind whimsical, airy words while the dramatic variation of pressure creates a moodier feel: weight, gravity, passion.

Finally, mastering this pressure on the pointed pen transforms what is possible with so many other tools. A lowly felt-tip marker or soft lead pencil takes on new possibilities once you've explored how each letter has different weight, and that weight comes from applying different pressure.

*"WHOEVER HAS TRIED TO FLY WILL WALK LOOKING UP AT THE SKY, BECAUSE THAT'S WHERE THEY HAVE BEEN AND THAT'S WHERE THEY WANT TO BE." (LEONARDO DA VINCI)

ora il volo

camminerà
guardando
il cielo,
perché là
è stato
e là
vuole
tornare

*

magie

DAL 1869

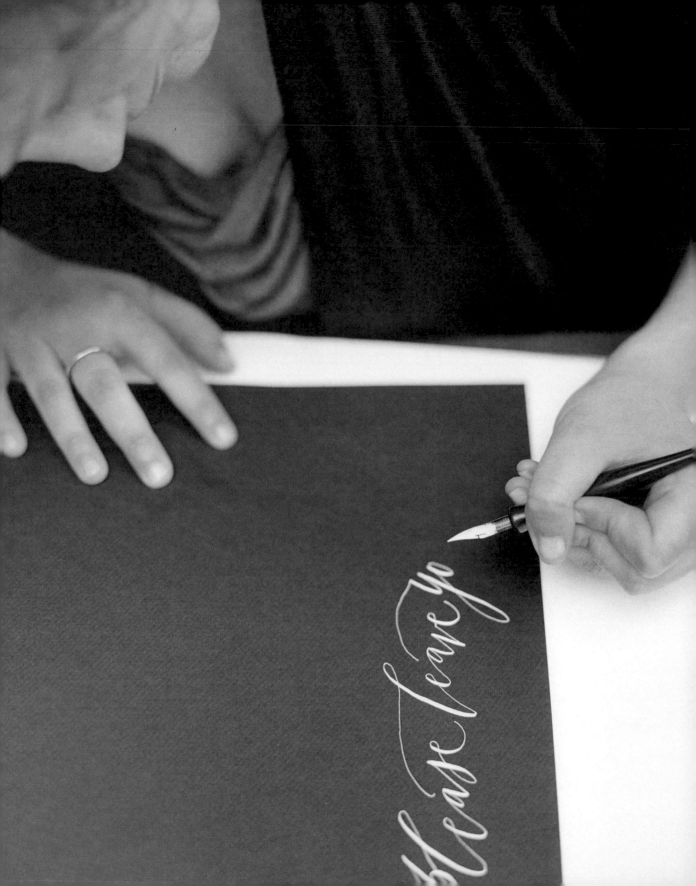

I AM LEFT-HANDED.

It's a common misconception that calligraphy is more difficult for lefties, but that is not so! Ensure you are using an upright calligraphy holder and not an oblique one. For everyone, but especially left-handers, the angle of everything matters: pen nib, holder, paper, wrist, torso, shoulders, hips, thighs, seat. Most of my teaching comes down to helping each student identify the angle for all of these things that feels best to them where all of these angles are aligned as harmoniously as possible. You can think of each of these lines like the slats of a fence: they should be parallel and lined up, instead of random and intersecting. Notice if you are contorting your wrist, crossing your legs or compressing your fingers.

★ **YOUR BODY SHOULD FEEL OPEN, COMFORTABLE AND ALIGNED.**

← *Left-handed calligraphers often need to move the paper so that it is almost perpendicular to their hand.*

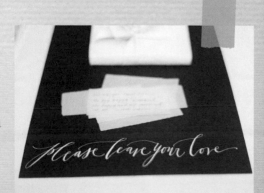

As calligraphy has become so popular in recent years, social media has become full of images and inspiration. Often I hear my workshop students say, 'I want my work to look just like this,' or, 'I can't do this. Mine looks horrible!' This breaks my heart because it means they are aspiring to be someone other than themselves, or they are unnecessarily judgmental, not of their artistic talent, but of who they are as people. I often see practitioners undertake calligraphy as a purely aesthetic hobby. There is nothing wrong with that, but there is so much more below the surface. Betty and I both believe that calligraphy can be an expression and exploration of our true selves, and it is constantly evolving. I'm astonished by how my style has changed over time. It is an indicator of my own growth and evolution. I think this is what writing offers for everyone who approaches it with curiosity and openness.

its already is

BY MARA ZEPEDA

THE POINT OF THE PEN

Most pointed-pen calligraphy is done with dip pens, which consist of a metal nib, or tip, attached to a handle called a nib holder.

Dip pens do not hold ink cartridges; instead, you constantly dip the nib into ink as you write. These are typically more flexible than fountain pens, as the nib can separate out, allowing you to achieve greater line variation, making both thick and thin lines by flexing, or bending open, as you press the nib onto the paper. Playing with this pressure is what creates endless possibilities when it comes to communicating emotion. Ensure you use bleed-proof paper when writing as the nib pen carries a lot more ink, which can blot otherwise and can catch and splatter on ragged forms of paper.

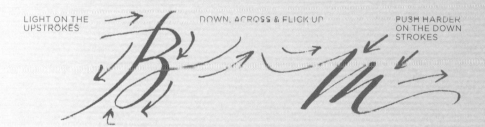

LIGHT ON THE
UPSTROKES

DOWN, ACROSS & FLICK UP

PUSH HARDER
ON THE DOWN
STROKES

Now that you have been getting back in touch with writing and have played with variations of letterforms, you will be able to apply those developments when you try using pointed pen. Once again, here there is a wonderful connection between breathing and writing – inhale on the upstroke, exhale as you push down...

your hands

UNDER PRESSURE

Getting a feel for pressure and the nib's flexibility is so much fun. The tines of the nib are quite flexible. You'll see that if you apply no pressure at all, the line is thin and light. The more pressure you apply, the thicker the line.

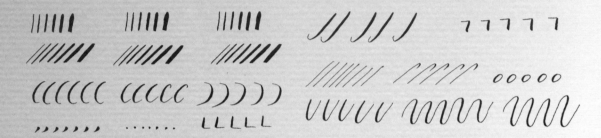

Now, imagine each line is the stem of a growing flower, like a delicate poppy. It might start light, wispy and fragile, and grow ever stronger and thicker.

Experiment with applying ever-increasing amounts of pressure to the nib to discover the variations of line weight.

hello

hello *hello*

hello *hello*

hello *hello*

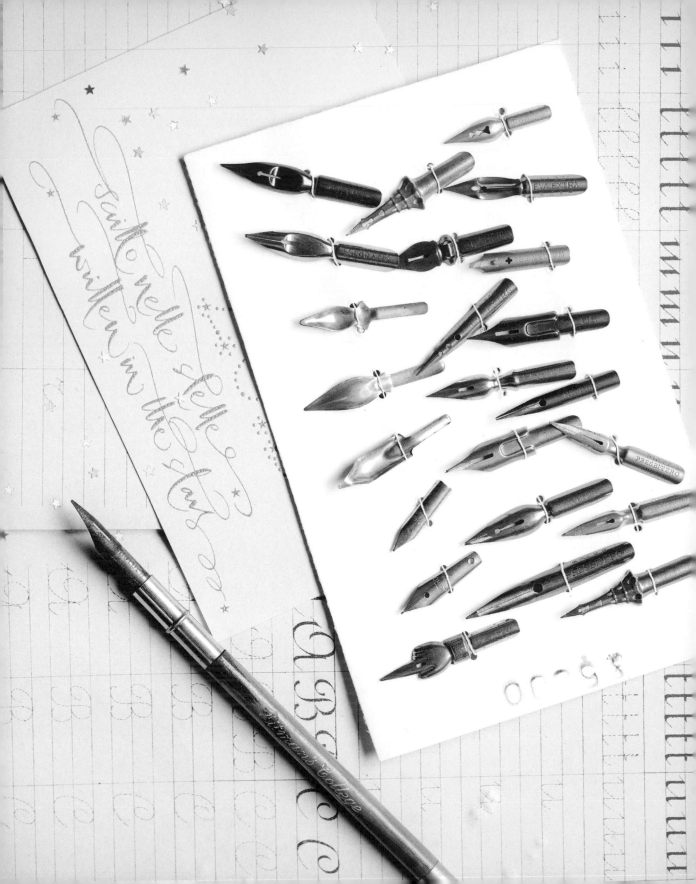

GRACE UNDER PRESSURE

In this Hemingway quotation you'll see that each line has a different letter weight, starting with light and hairline in the first line, and moving towards thick and bold in the final line. Choose your favourite quote and play with 'progressing' the letters' weight as you go.

courage is grace under pressure. ernest hemingway

E-MOTION!

Line weight can also communicate different emotions, from playful and whimsical to strong and assertive. Channel your emotion onto a page and let the letter alignment, line weight and spacing communicate those feelings.

La vita è una combinazione di magia e pasta *
FEDERICO FELLINI

INKED

Throughout this book, you will see some of the creative ways that Betty takes her calligraphy off the page, from writing on walls to decorating food. Designing calligraphy tattoos has been one of the most remarkable experiences of my life and one of the ways that I take my work off the page. I collaborate with clients to create a piece of calligraphy that is meaningful to them, and they then take it to a tattoo artist to have it inked onto their skin. It is a remarkable feeling to see my work shared in this very personal and permanent way. It's just another possibility when it comes to bringing your calligraphy to life.

**'WHEN PEACE LIKE A RIVER ATTENDETH MY WAY,
WHEN SORROWS LIKE SEA BILLOWS ROLL,
WHATEVER MY LOT, THOU HAST TAUGHT ME TO SAY
IT IS WELL, IT IS WELL WITH MY SOUL.'
– HORATIO SPAFFORD**

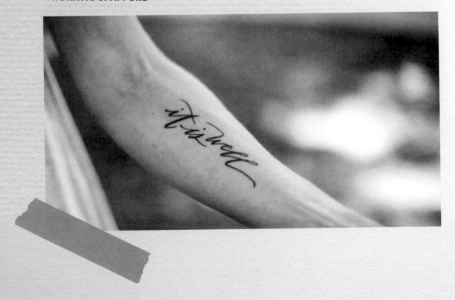

trós

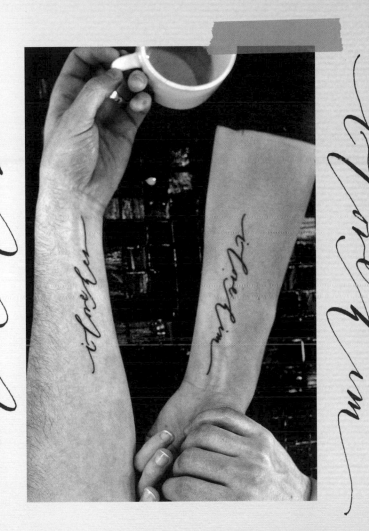

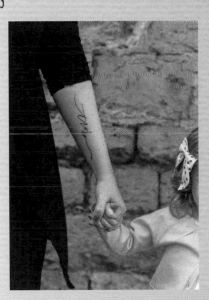

> **ENJOY YOUR EXPLORATION OF POINTED-PEN CALLIGRAPHY.**
> **LET ME HAND YOU BACK TO BETTY TO ENCOUNTER NEW WAYS OF LOOKING AT WORDS.**

Mara

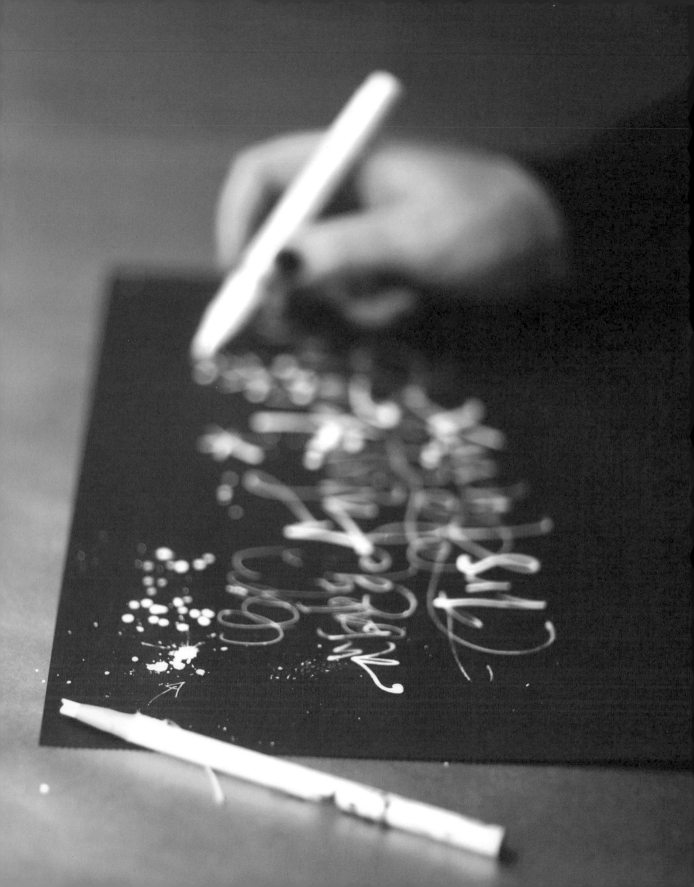

WORDS MATTER

Making a change to your materials or medium can alter how you experience the words you are writing. Writing white on black, for example, completely changes your perception of writing. The fastest way you can start to develop your own calligraphic voice is to practise with white on black, no longer tracing or copying my letterforms. So fly into the the blackness of the following page and learn to fly by writing in your own style. Cherish every inky star you make...

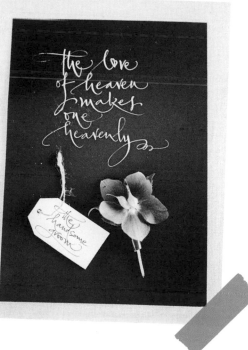

WRITE IN WHITE

On this page, try writing with a white acrylic paint marker pen, such as a Uni POSCA pen. Alternatively, shave a china marker pencil or even use chalk – watch your words appear like stars on a black sky...

Are the stars just pinholes in the curtain of night?

PAPERCUTTING QUEENS

—

I couldn't write a book about inkspiration without telling you about two more women who have had a huge influence on me. Of the amazing encounters that have crossed my inky path, meeting the statuesque sisters Simone and Helene marks an amazing chapter in my paper cosmos.

A DOUBLE DOSE OF SCISSOR POWER, THE EDITION POSHETTE TWINS HAVE PURE POETRY IN THEIR HANDS.

They are incredibly talented papercutting artists, making the most remarkable paper creations at astonishing speed.

My calligraphy took on a different dimension once the sisters began taking my inky scribbles and turning them into papercut feathers, flowers, birds and bouquets.

All the amazing paper designs that appear in these pages were cut, pleated, shaped and formed by them. They are stylists, artists and true friends.

Our collaborations have generated so many wonderfully creative moments – ranging from our printed leather accessories to their extraordinary design of the 'paper room' at one of our hotels. Lying in bed, you contemplate an illuminated paper cut-out skyline of Florence, with folded books above your head to give you sweet and clever word-filled dreams.

The combination of my inkiness with their uber-talents and *joie de vivre* was the initial spark to the making of this book, and above all, we cherish our time together to make and share what we do.

↗ *Papery details from the room the twins decorated at SoprArno in Florence.*

→ *One of our creative collaborations on Edition Poshette printed leather accessories.*

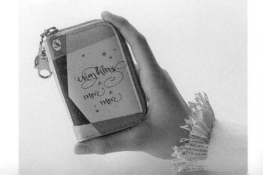

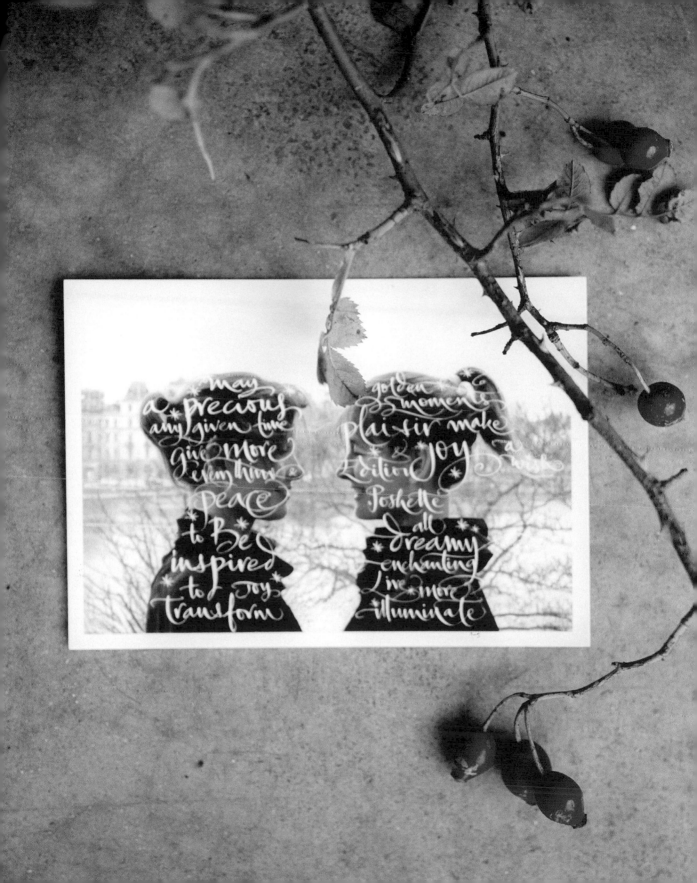

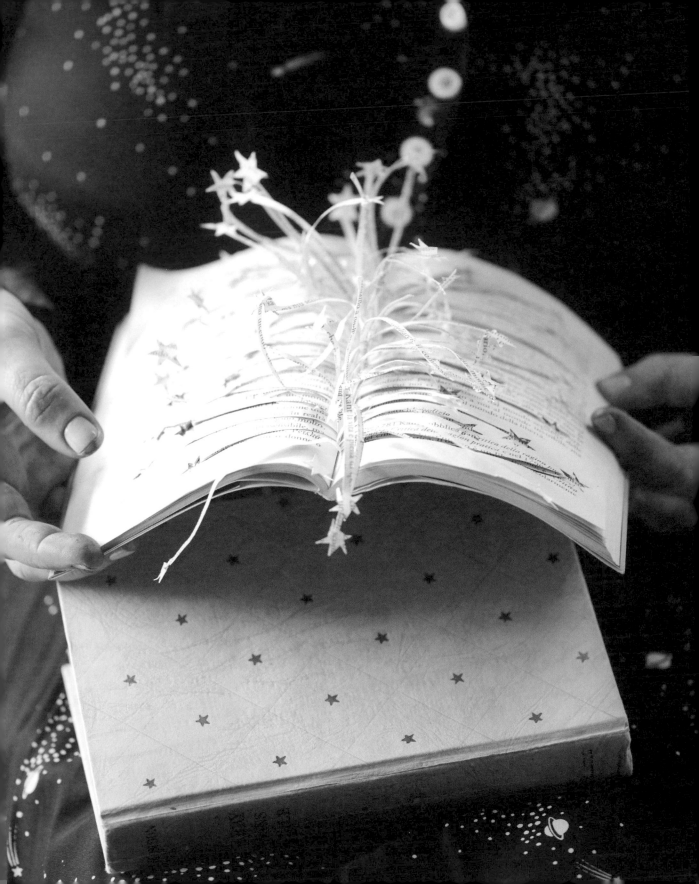

...it doesn't matter how the paint is put on, as long as something is said...

(JACKSON POLLOCK)

↗ *'Inkspired' pleated paper cuff, letters hand-cut with scissors by Edition Poshette using one of my handwriting sheets.*

← **IT'S ALL WRITTEN IN THE STARS**
One of my favourite papercut Edition Poshette creations: a literal book of stars that speaks magic and poetry just by being there...

I hope that seeing some of the Edition Poshette papercut magic in these pages will give you ideas for different ways in which you can bring your calligraphy to life. From Christmas decorations and bookmarks to paper fans, just a few snips of the scissors can help your words leap off the page.

Let's bring writing to life and share it with those around us.

BRINGING WRITING TO LIFE

As you develop your own style, bring in different moods for different occasions, and also express yourself on different surfaces, trying out a variety of writing tools and finding ones that feel great for you. Move away from just writing on paper or card – try writing words for others to notice in unexpected places or in ways that will surprise them. The tools you use matter less than the ideas you have, and the simplest idea becomes precious once it becomes personalised by you.

SAY IT WITH FLOWERS

Instead of a card, take a large piece of paper and write your message all over it. Wrap the paper around the bouquet. You can do the same to create personalised wrapping paper for gifts.

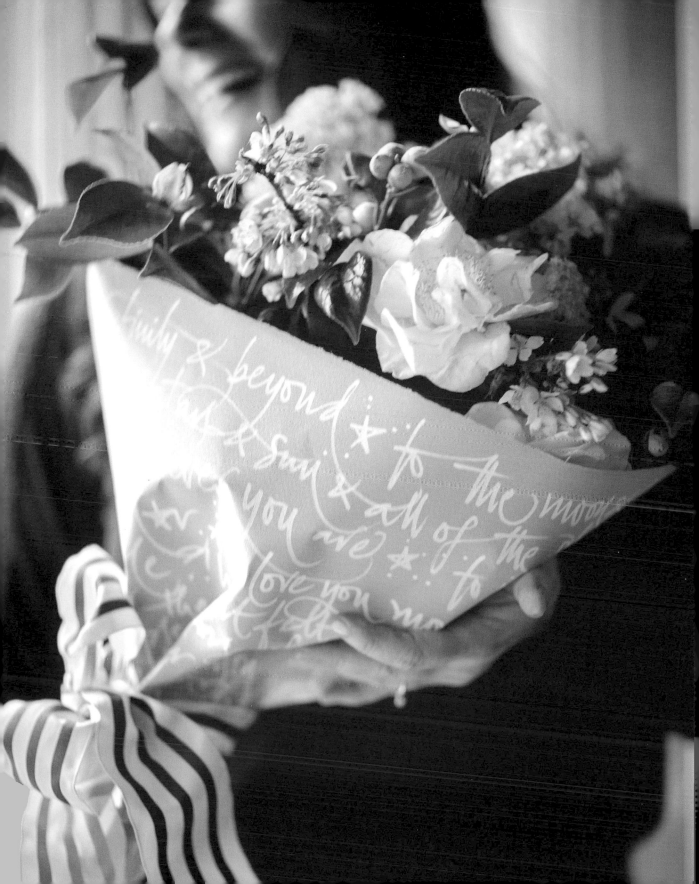

...r wedding day is one that
...ems to fly. It's a day filled
...ith emotion, friends, rings a
...nces. So take a few seconds to
... into each other's eyes. Think
...nt the happiness you are feeling
...his place, in this moment.
...ally let that feeling register in
...heart and mind. Now dream
...nt the future together, in each
...'s arms x hearts x minds x

John Lennon ONCE SAID:
"A dream you dream alo...
is only a dream a dream you
dream TOGETH...
that is realit...

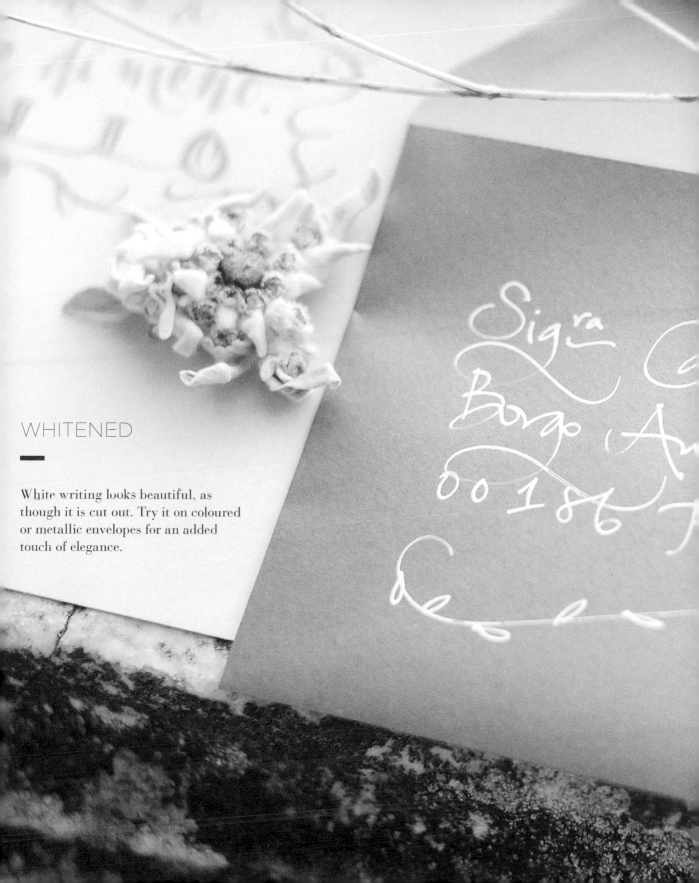

WHITENED

—

White writing looks beautiful, as
though it is cut out. Try it on coloured
or metallic envelopes for an added
touch of elegance.

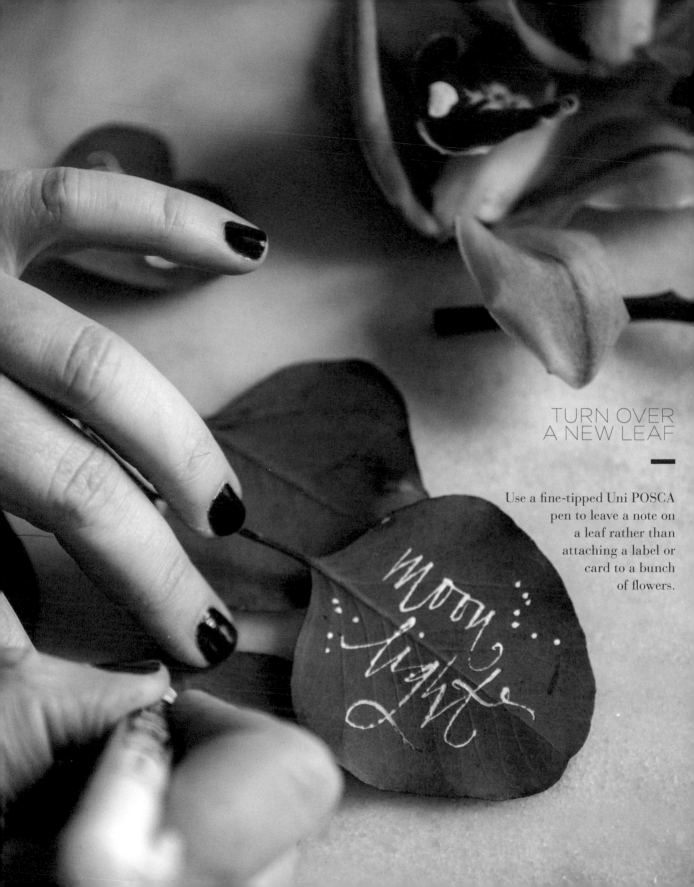

TURN OVER
A NEW LEAF

—

Use a fine-tipped Uni POSCA pen to leave a note on a leaf rather than attaching a label or card to a bunch of flowers.

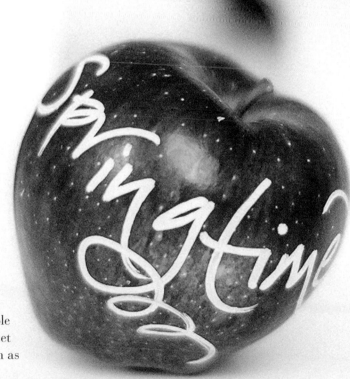

SWEET BITES

—

Uni POSCA pens can write on almost any surface.
Try using them on a piece of hard fruit, like an apple
or a pear – the ink will easily wipe off. Sneak a sweet
message into your loved one's lunchbox, or use them as
creative place settings at a dinner party.

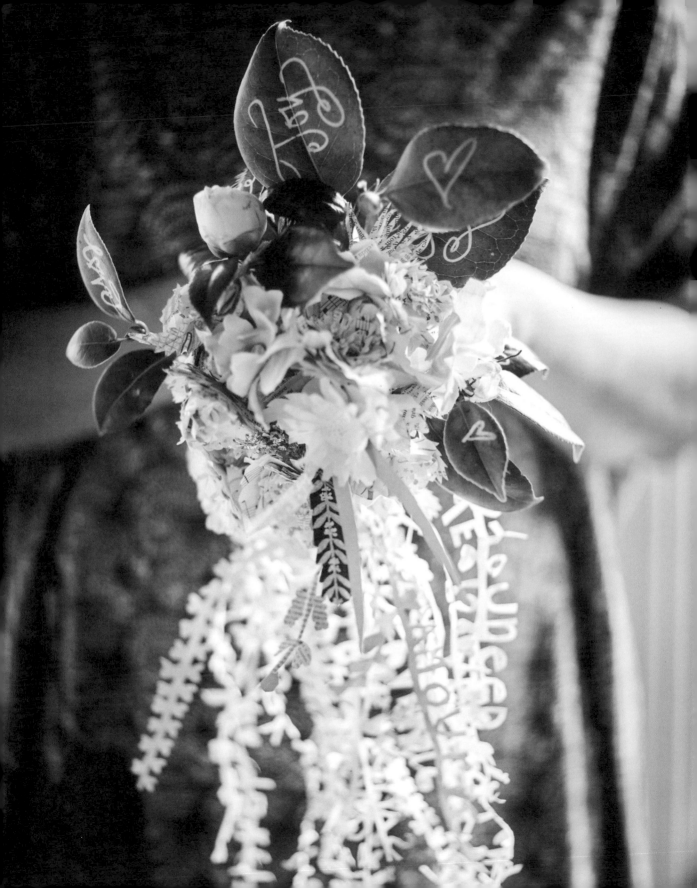

PAPER MAGIC

Although there is something very beautiful about the transience of flowers and leaves, sometimes we want special moments to last. Incorporating paper cutouts or drying leaves from a bouquet gives you something to keep afterwards.

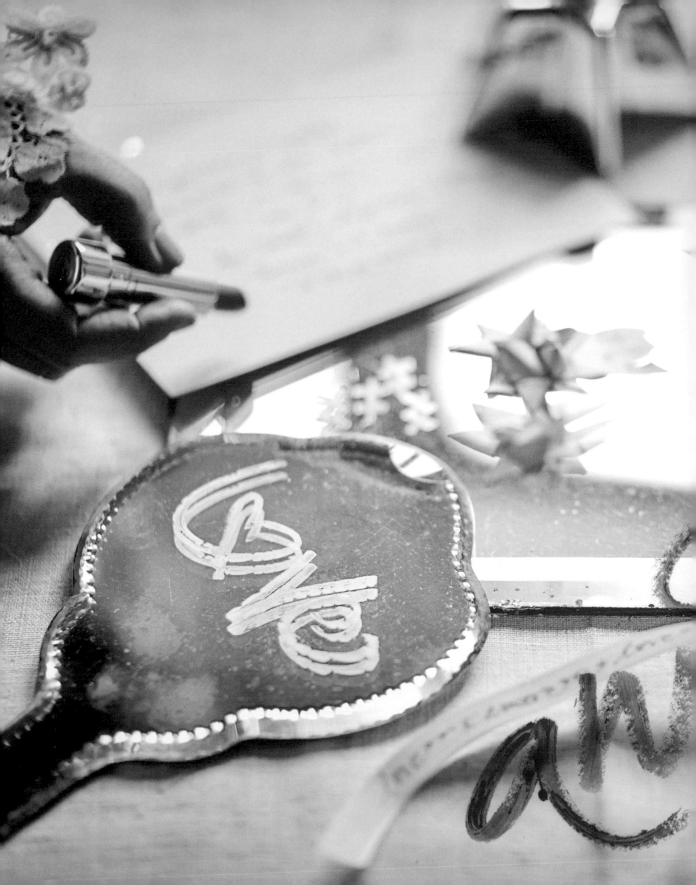

VERY VALENTINE

There is something luxurious and romantic about writing with lipstick. Try it on a mirror – it glides richly across the surface and leaves a deeply colourful and textured mark. Leave a note for someone in the looking glass – or a little something to make yourself smile next time you see your reflection.

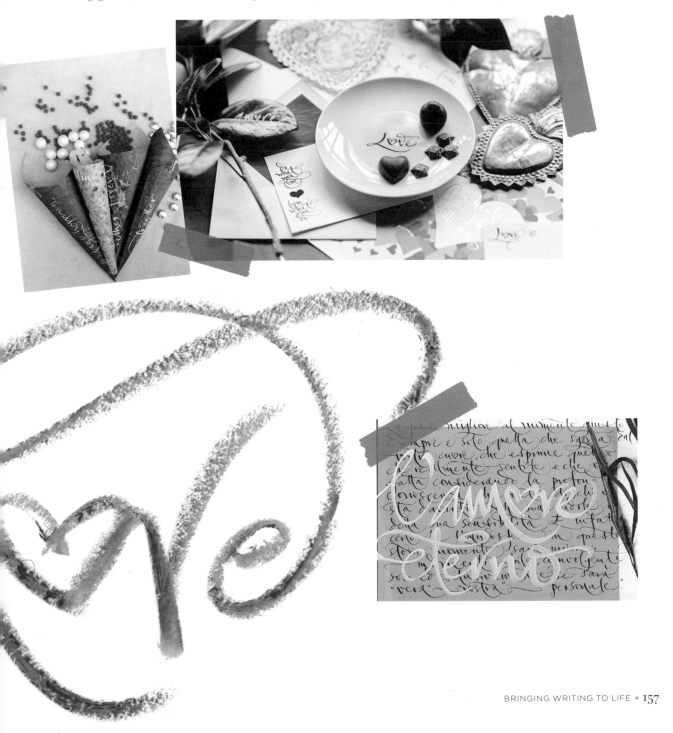

Love love

May you touch
dragonflies & stars,
dance with
the fairies
& talk
to the moon

WEDDING BELLS

I am often asked to create bespoke wedding invitations for clients – and there are many ways to bring inky beauty into the proceedings. From menus and vows to napkins and gifts, taking the time to create exquisite personalised messages makes everything even more special.

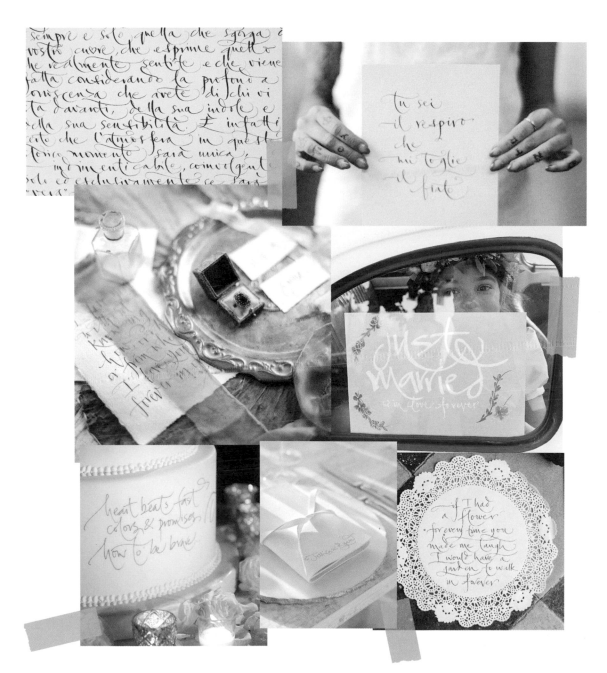

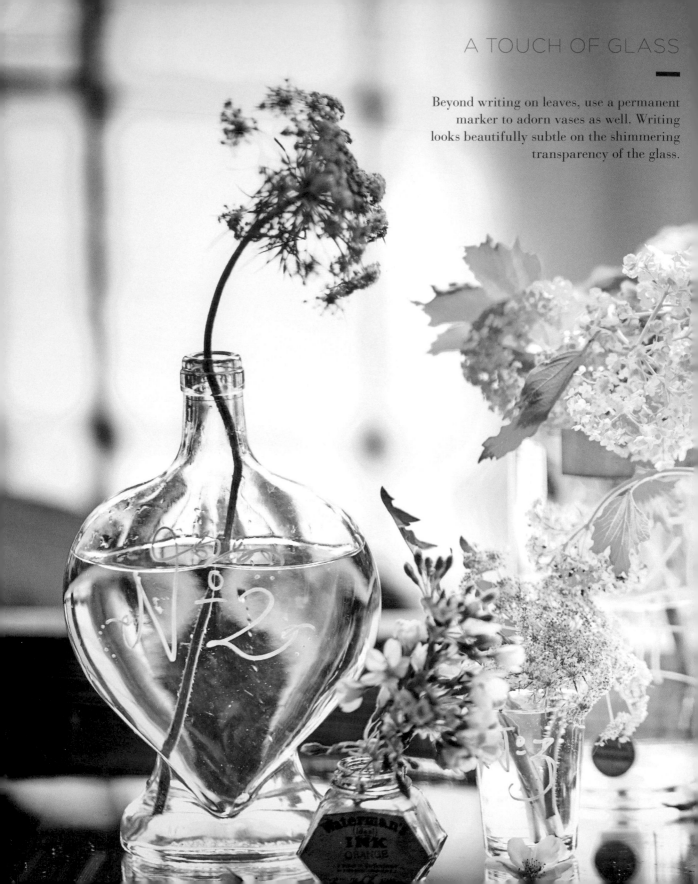

Beyond writing on leaves, use a permanent marker to adorn vases as well. Writing looks beautifully subtle on the shimmering transparency of the glass.

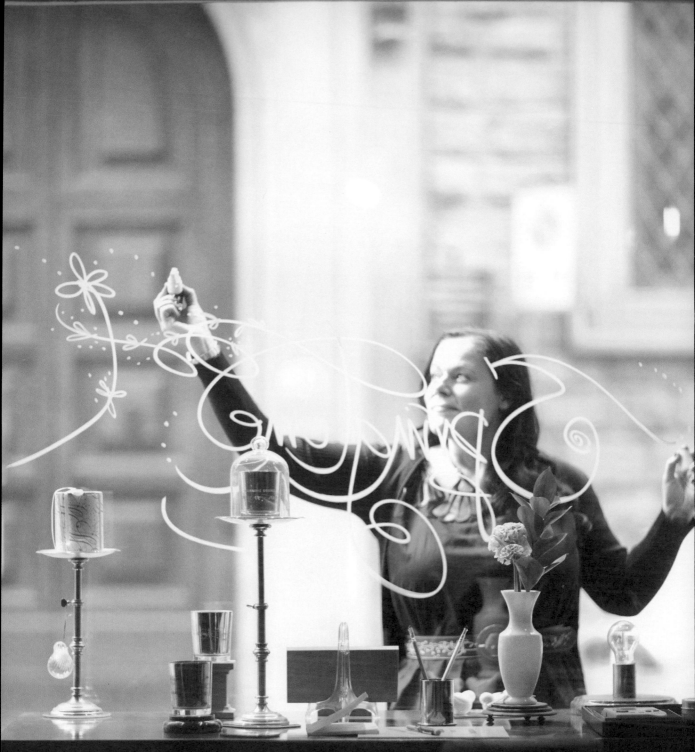

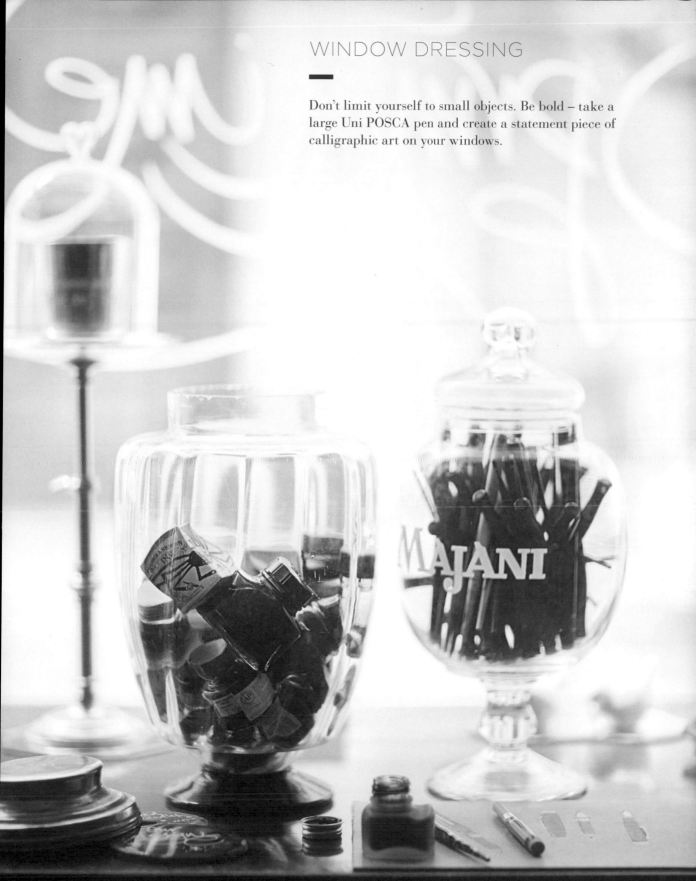

WINDOW DRESSING

Don't limit yourself to small objects. Be bold – take a large Uni POSCA pen and create a statement piece of calligraphic art on your windows.

Writing on mirrors is a fun way to raise a smile or add another layer to glass photo mounts and box frames. Uni POSCA pens wipe off easily, so you can make your words flutter away.

The beauty
you see in me
is a reflection
of you

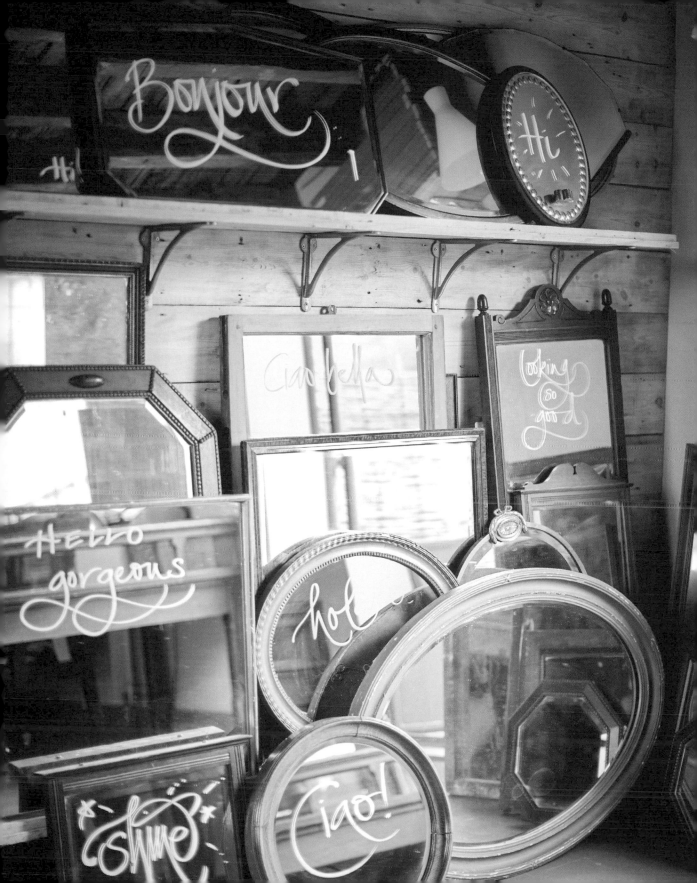

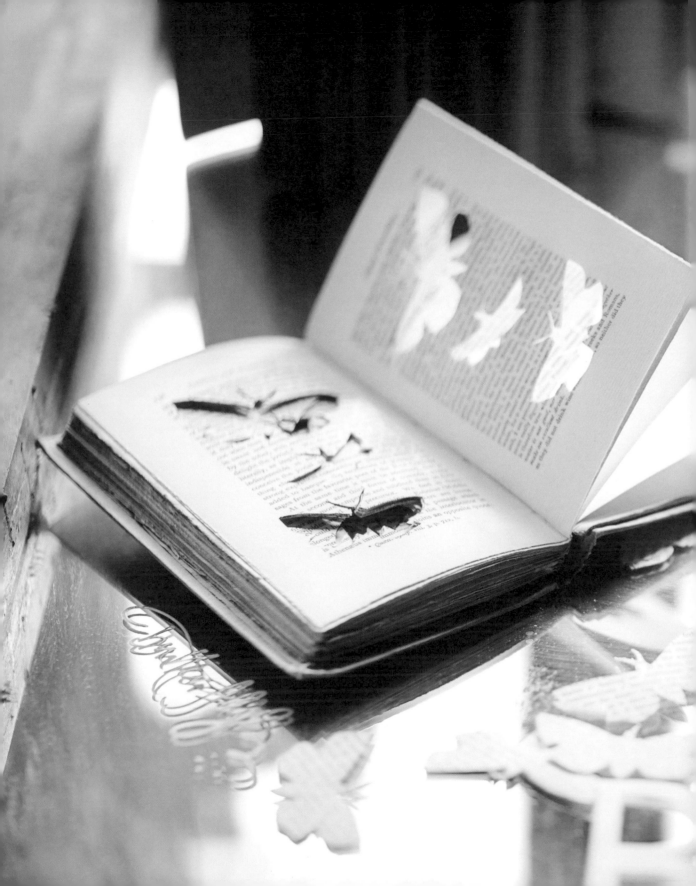

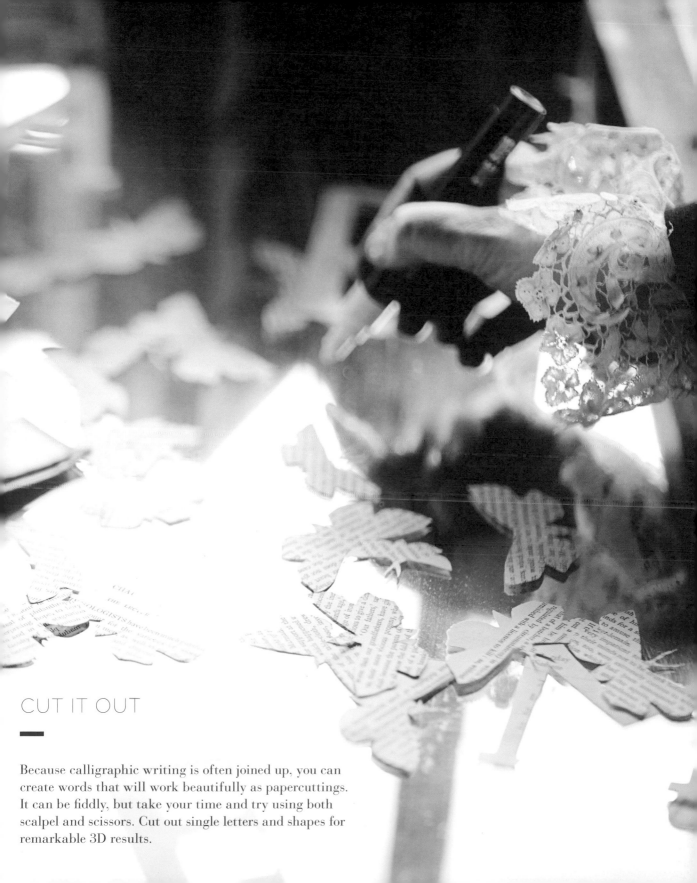

CUT IT OUT

—

Because calligraphic writing is often joined up, you can create words that will work beautifully as papercuttings. It can be fiddly, but take your time and try using both scalpel and scissors. Cut out single letters and shapes for remarkable 3D results.

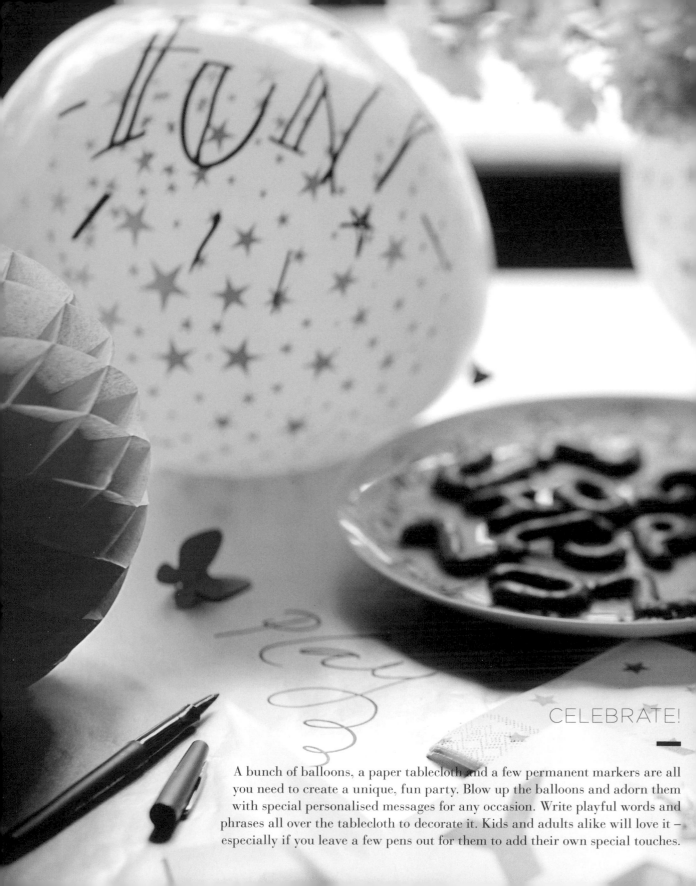

CELEBRATE!

A bunch of balloons, a paper tablecloth and a few permanent markers are all you need to create a unique, fun party. Blow up the balloons and adorn them with special personalised messages for any occasion. Write playful words and phrases all over the tablecloth to decorate it. Kids and adults alike will love it – especially if you leave a few pens out for them to add their own special touches.

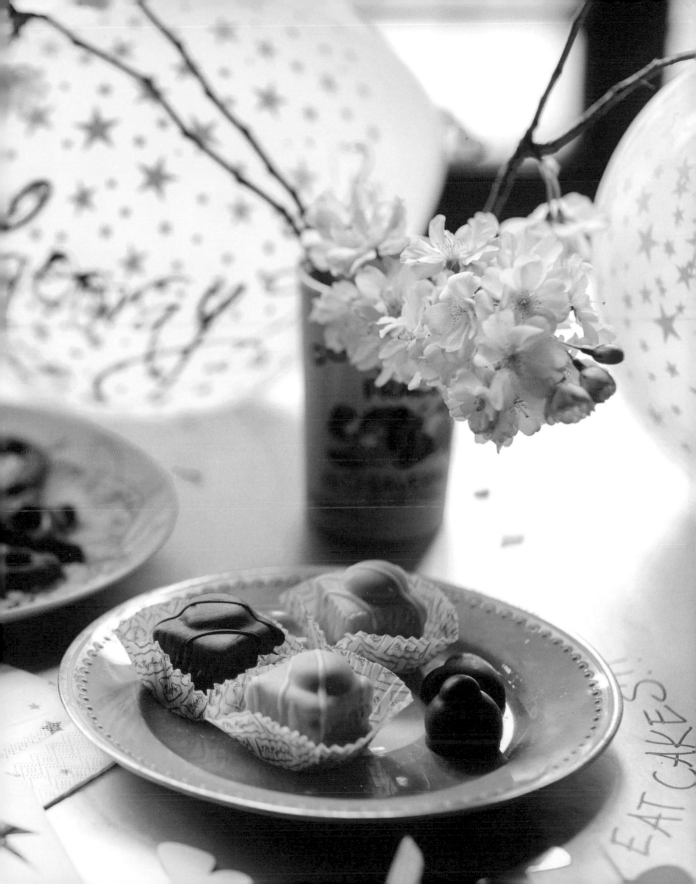

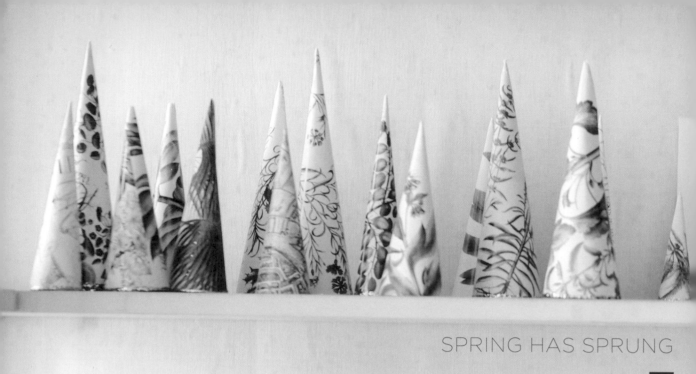

SPRING HAS SPRUNG

Spring is one of my favourite times of the year –
everything feels fresh, new and full of flourishing
potential. Celebrate it by giving unexpected gifts
to your favourite people. Use plain paper bags, and
with a few strokes of any kind of pen, they become
something seasonally special and utterly you.

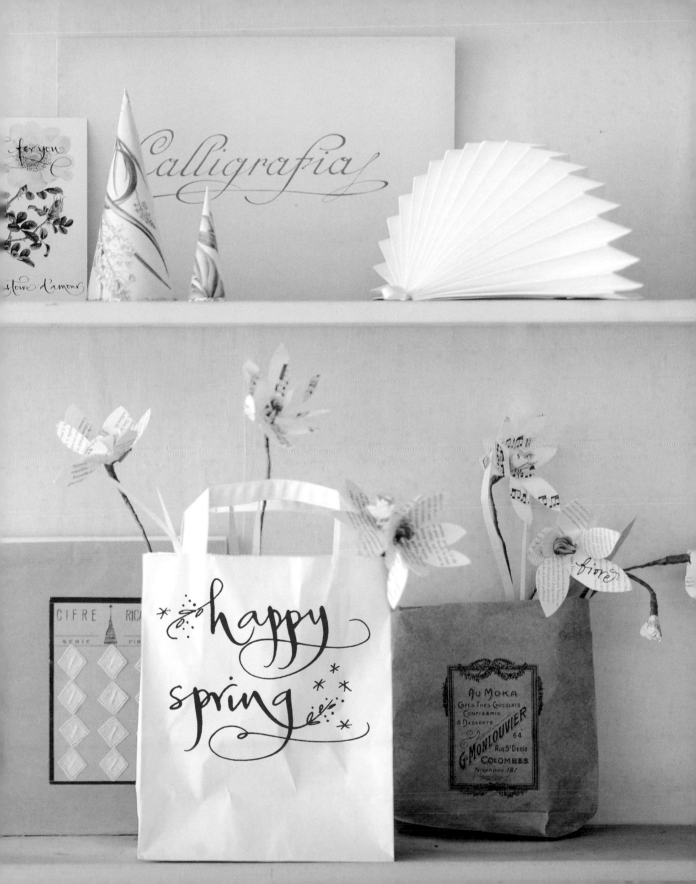

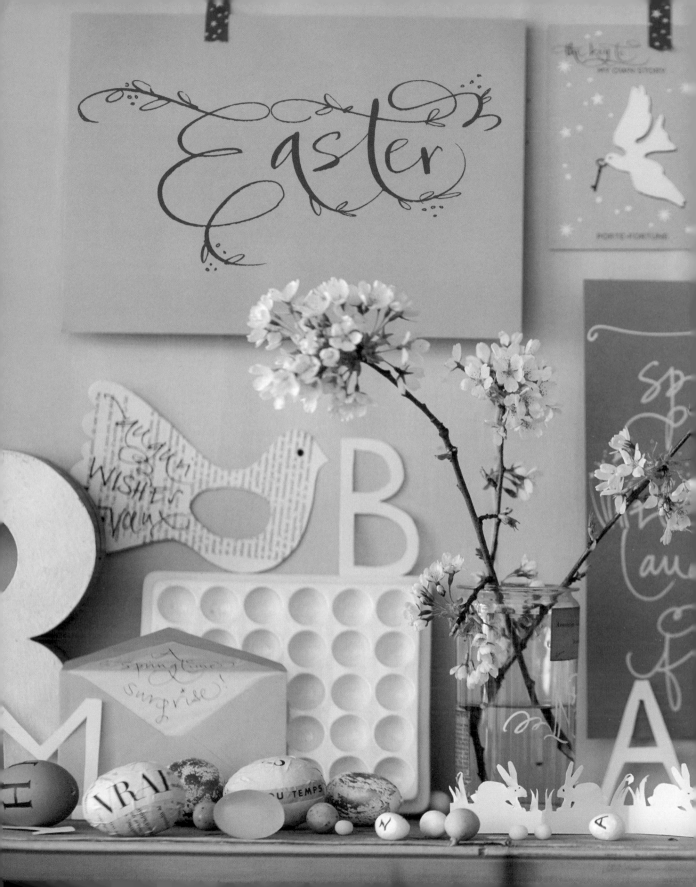

GATHER GOOD THINGS

Writing your dreams, wishes and desires on seasonal items is a great way to create festive displays all year round.

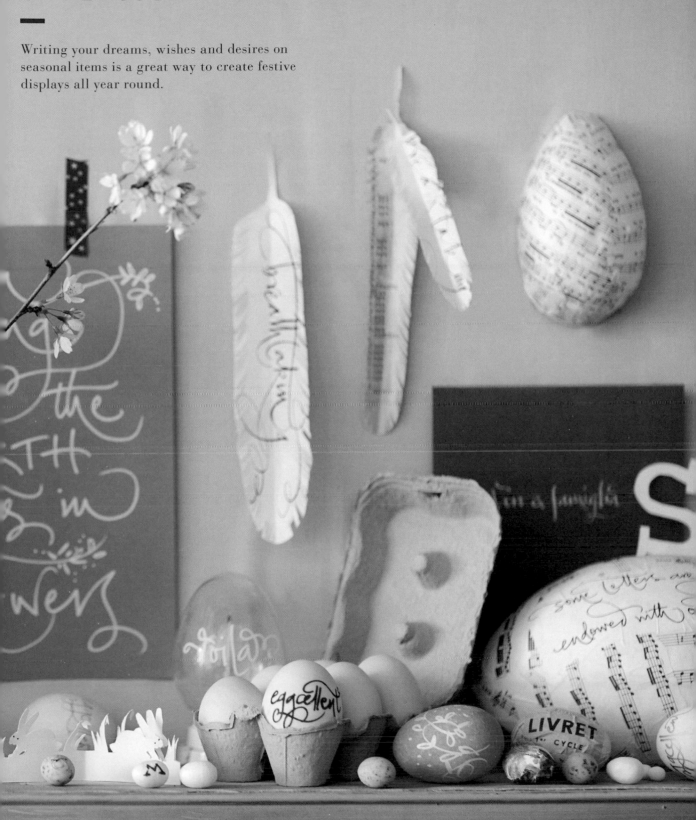

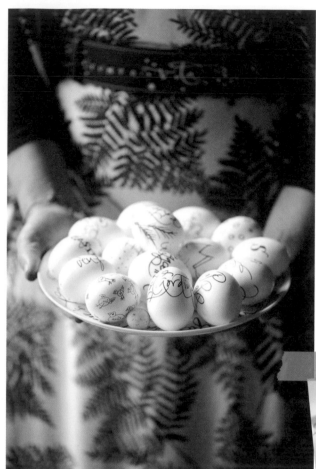

EGGCELLENT IDEA

Of course, we all love chocolate eggs, but you can use the real things to create beautiful Easter displays. Either make a hole with a pin and let the yolk flow out, then rinse, or just hard boil them. Now adorn them with Easter messages, words, splashes, drawings and patterns in permanent markers of all sizes. A restricted colour palette is stylish, but let children go crazy doodling all over them with coloured pens!

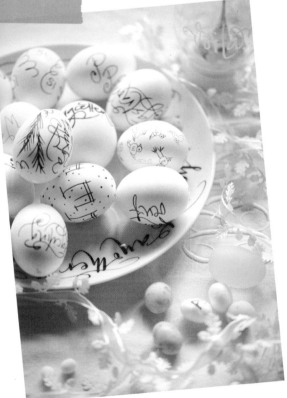

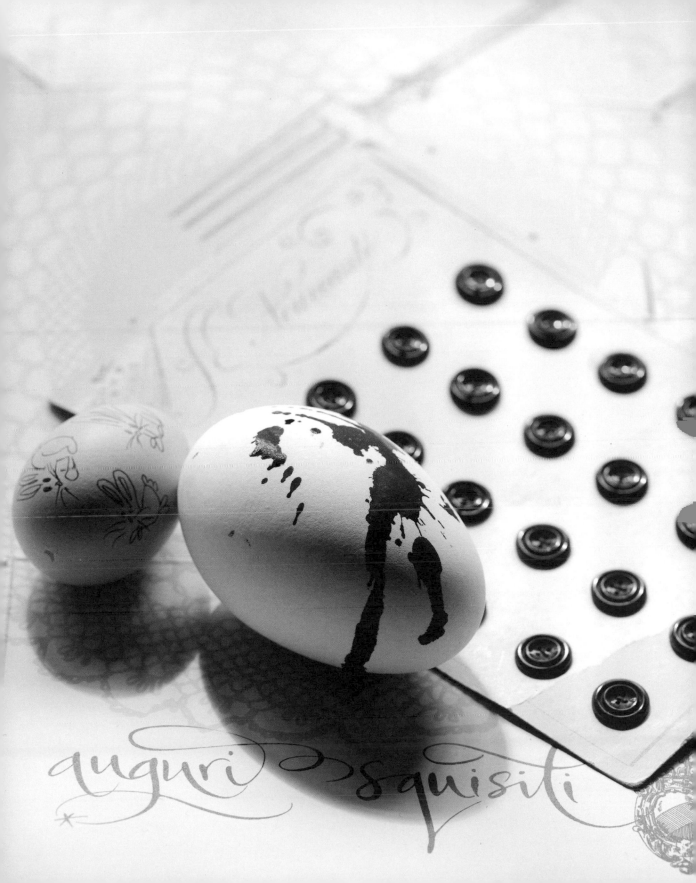

auguri squisiti

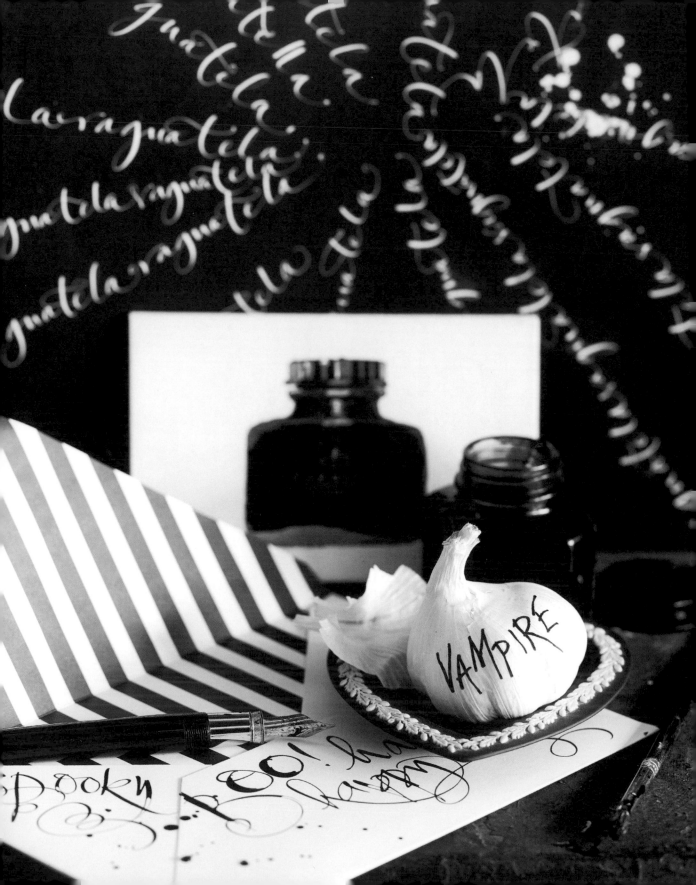

TRICK AND TREAT

Use black ink and spiky lettering to create eerie Halloween messages, or make a piece of scary lettering artwork in the shape of a web. Use paint or permanent markers to write spooky phrases on pumpkins for a classy and modern alternative to carving them into lanterns. Remember to scribble on a bulb of garlic to keep the vampires at bay...

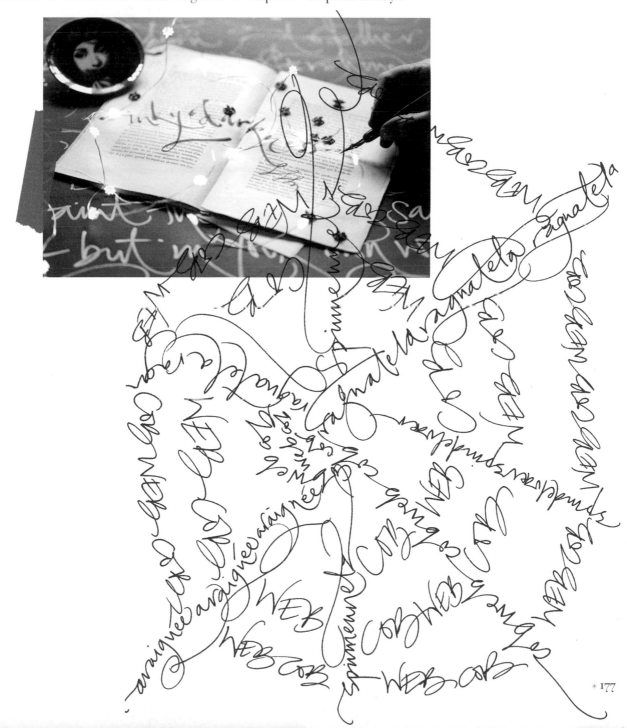

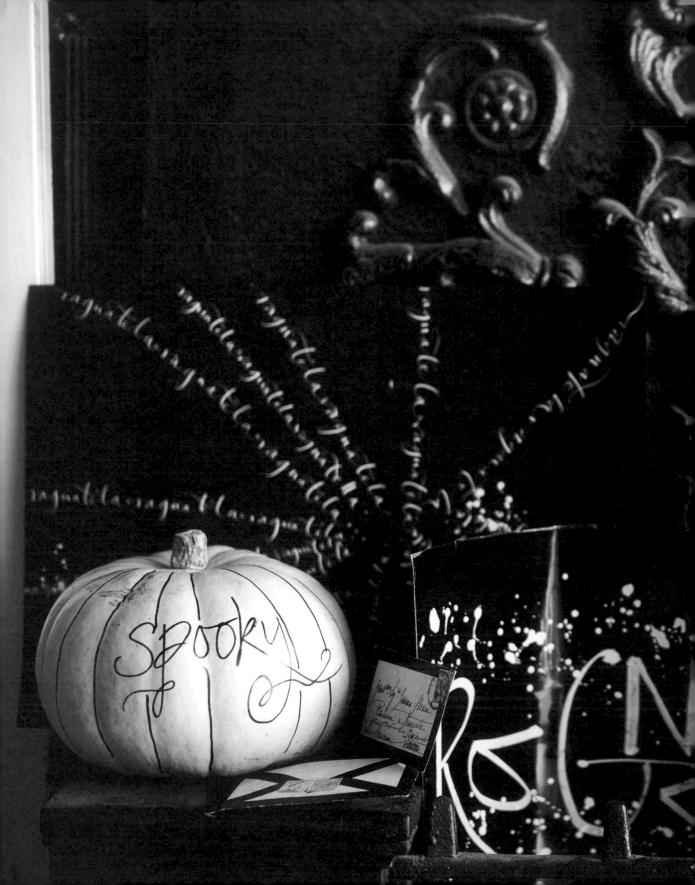

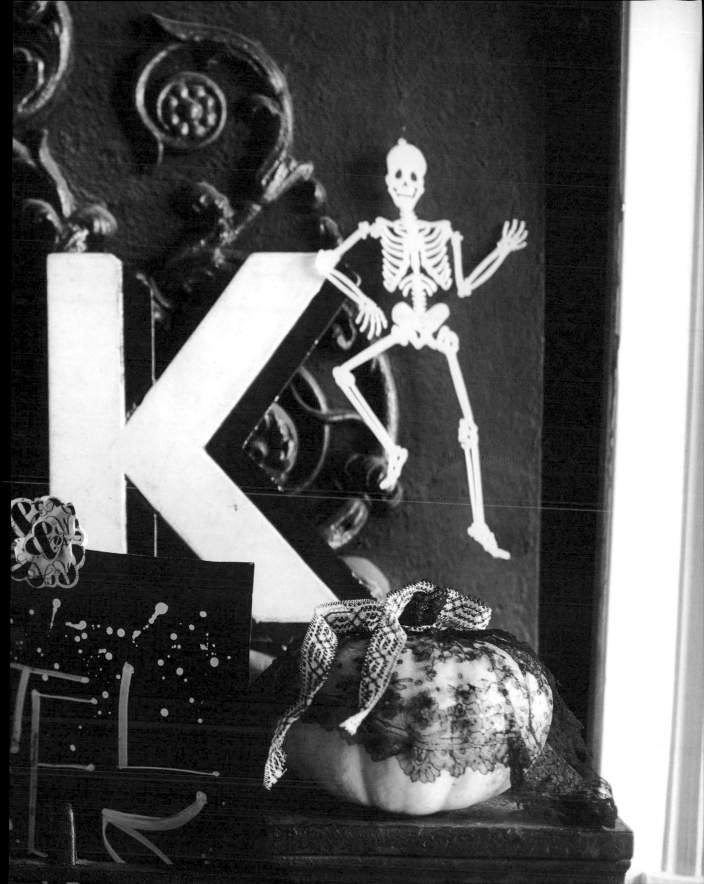

Calligraphy is a great way to create your own personalised
Christmas decorations. Plain glass baubles work best –
write large festive words on each one with a metallic pen.
Finish with beautiful ribbon for a truly terrific tree.

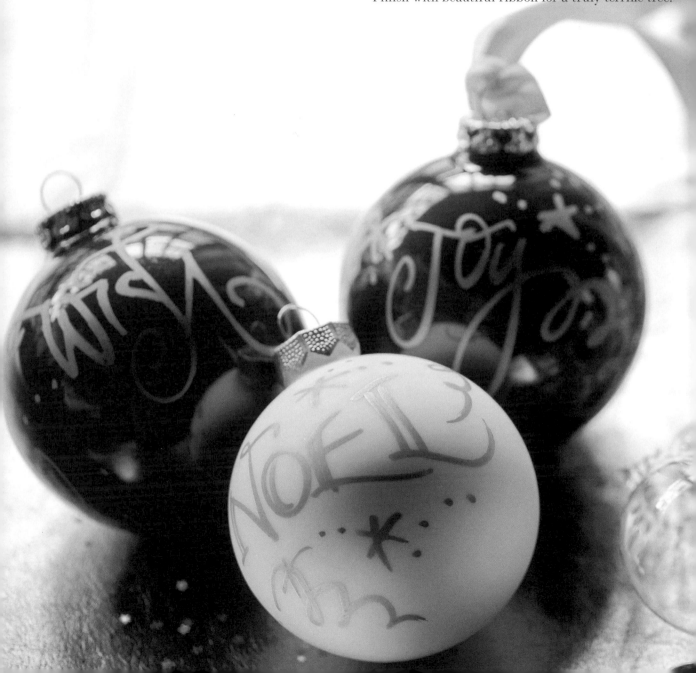

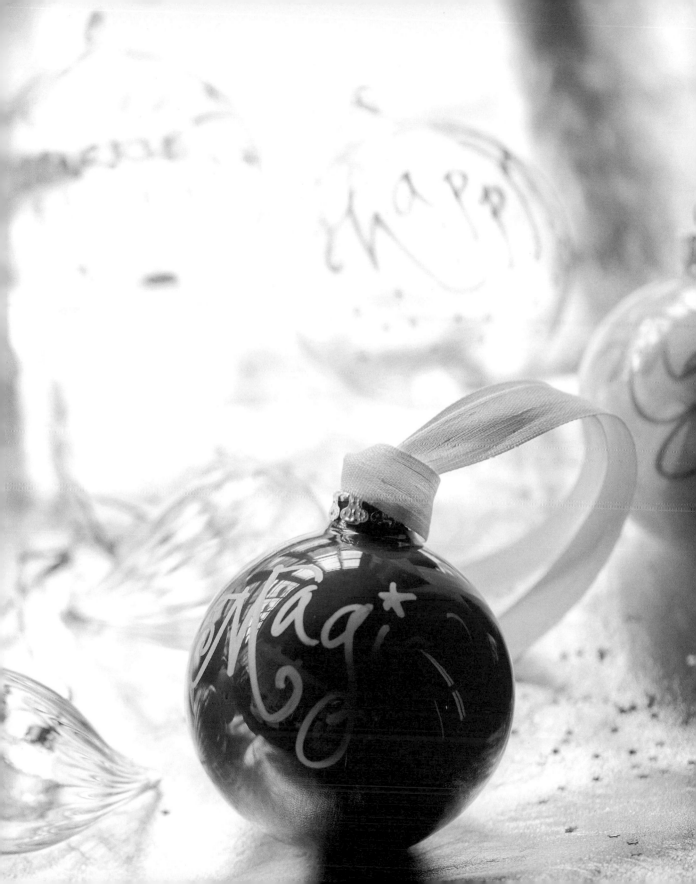

Write a joyful message directly on a wine or champagne bottle with a metallic Sharpie or Uni POSCA pen. It's an original way to make the gift of a bottle at a dinner party feel super-special – and it looks great on the table too.

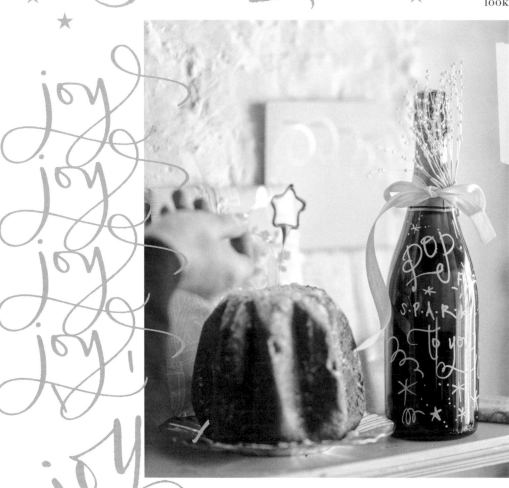

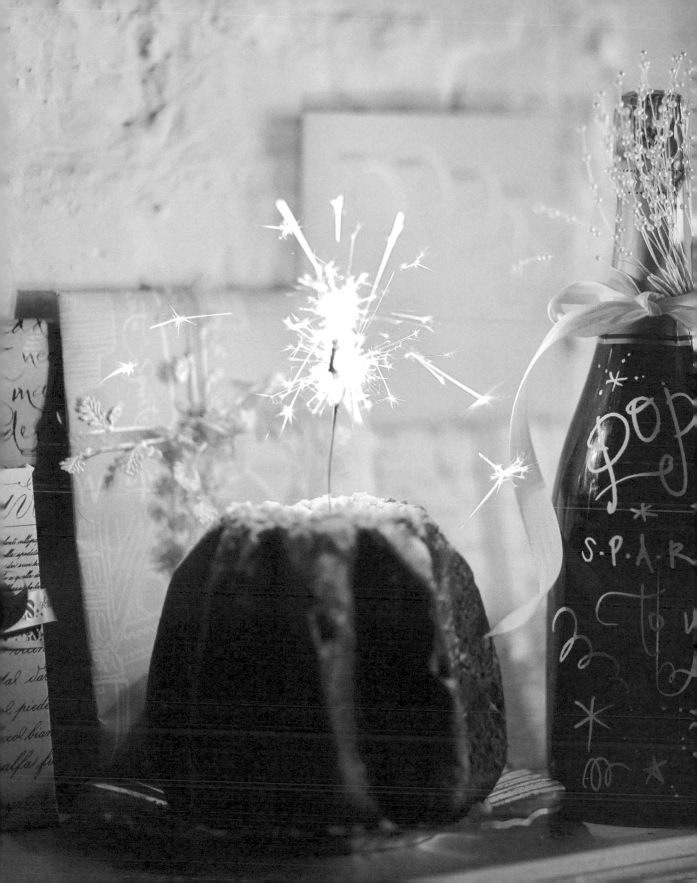

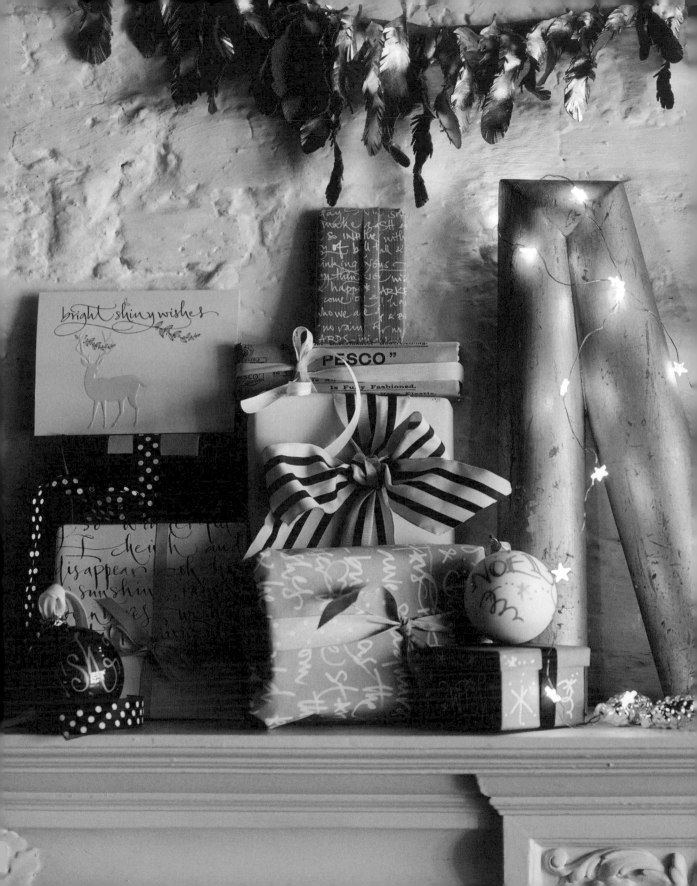

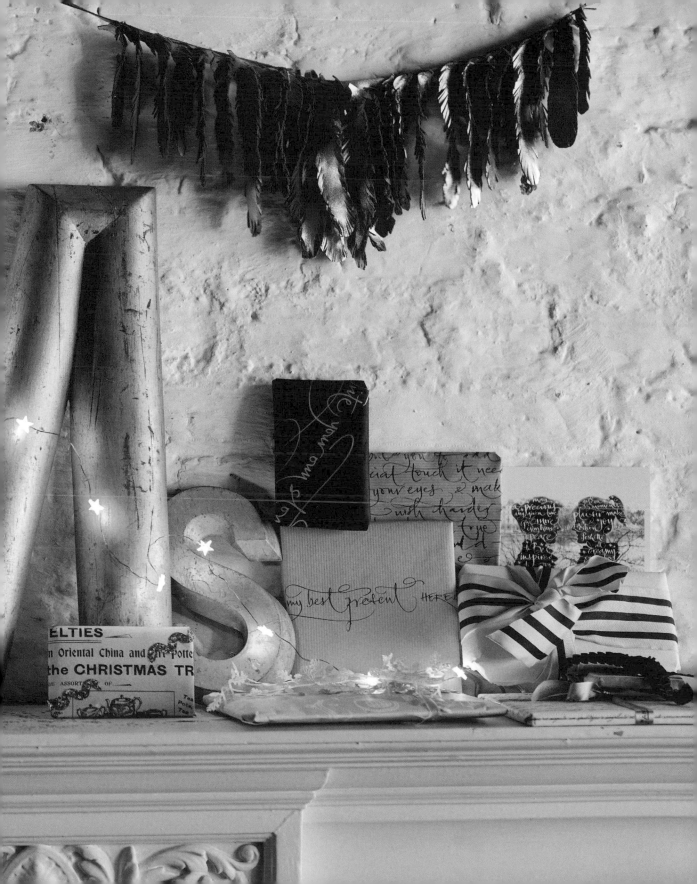

CREATIVE CHRISTMAS

Use your calligraphy to make your Christmas unique and beautiful. Start with plain envelopes, card and paper, and spend some time covering them in joyful lettering and tidings of good cheer in contrast script. Add a personal touch to your gifts, from writing a dedication on the title page of a book to adding whimsical wording to a candle. Now wrap everything up in your own personal inkiness.

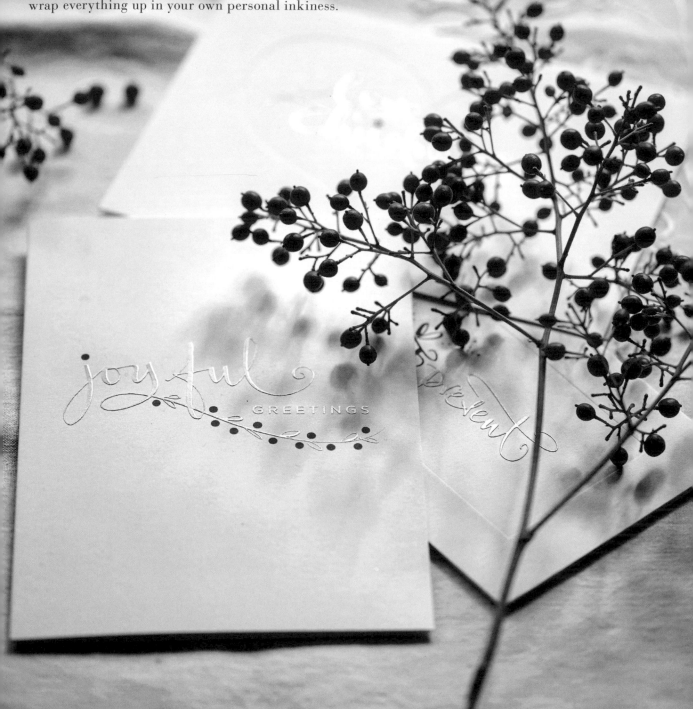

happy everything

anguri stellati

have a
holly jolly
Christmastime
and all good wishes
for a happy new year

merry & bright

joyeux tout

starfilled wishes

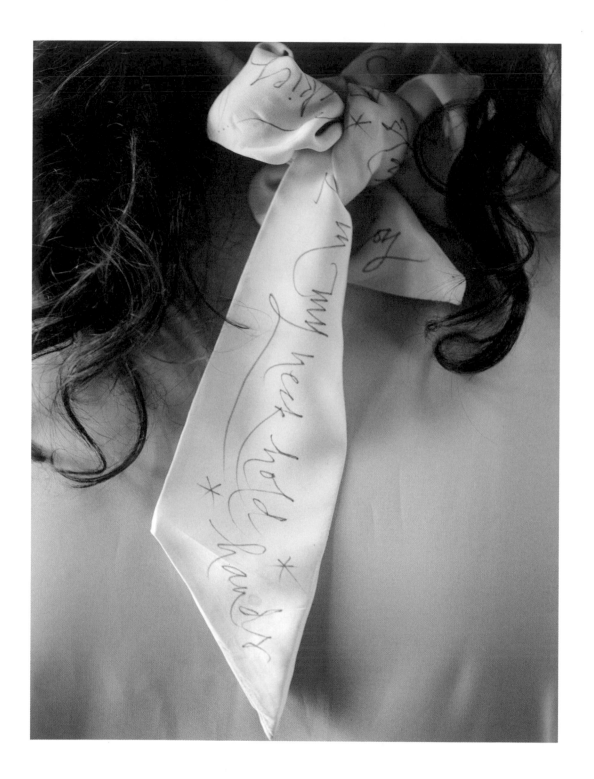

it's all written in the stars

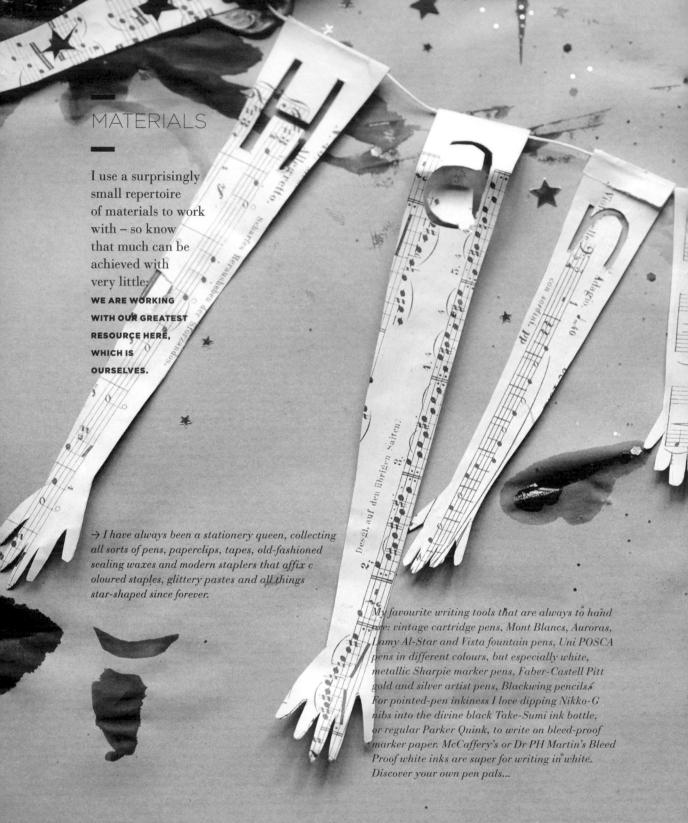

MATERIALS

I use a surprisingly
small repertoire
of materials to work
with – so know
that much can be
achieved with
very little;
**WE ARE WORKING
WITH OUR GREATEST
RESOURCE HERE,
WHICH IS
OURSELVES.**

→ *I have always been a stationery queen, collecting
all sorts of pens, paperclips, tapes, old-fashioned
sealing waxes and modern staplers that affix c
oloured staples, glittery pastes and all things
star-shaped since forever.*

*My favourite writing tools that are always to hand
are: vintage cartridge pens, Mont Blancs, Auroras,
Lamy Al-Star and Vista fountain pens, Uni POSCA
pens in different colours, but especially white,
metallic Sharpie marker pens, Faber-Castell Pitt
gold and silver artist pens, Blackwing pencils.
For pointed-pen inkiness I love dipping Nikko-G
nibs into the divine black Take-Sumi ink bottle,
or regular Parker Quink, to write on bleed-proof
marker paper. McCaffery's or Dr PH Martin's Bleed
Proof white inks are super for writing in white.
Discover your own pen pals...*

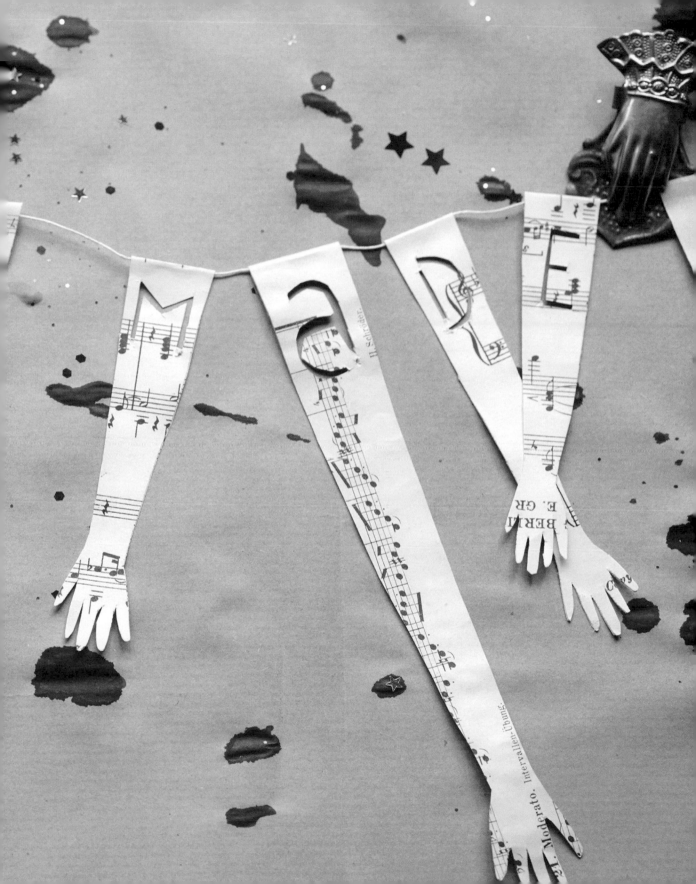

THANK YOU

To my visionary parents Dante and Mirna, and potent sister Marinella, who constantly encourage me to reach for the stars.

To Matteo and Alma, who indulge my starry-eyed daydreaming and always patiently wait for me to scribble yet another inky something before we all go out to play.

With starfilled thanks to anyone who has inkspired me along the way, probably without knowing it, and especially to my friends as we nurture each other along our inky paths...

Special thanks for all the help and joy in the making of this book to Mara, the Edition Poshette twins Simone and Helene, Adam and Maria at Retrouvius, Crawford, Kathy, Frances, Veronica and Claudia.

Thanks to Debi for our wonderful creative time together, to Tara and the team at Kyle Books who enthusiastially approached me to do this book and then gave me complete creative freedom to make it all happen.

TO DISCOVER & BUY:
bettysoldi.com
soprarnosuites.com
adastraflorence.com
andcompanyshop.com

editionposhette.com
marazepeda.com
neithersnow.com
retrouvius.com
mountstreetprinters.com

Laure Mina
Giaco & Matti Perdu
Punter Carolyn
Frances Alexandra
Chloe Christina Sl
Veronica Caitlin A
Giulia Sofia RAM
Fridou Moni Kathy
Simone Helene M
& everyone who insp